JOURNEYS
with the
GLOBAL FAMILY

**The cover painting
is described on page 32**

Jerry & Sandy

I truly enjoyed meeting you! Enjoy
your journey through the soul of my art,
insights & global adventure!

your artist author & friend

R Padre

JOURNEYS
with the
GLOBAL FAMILY

insights
through
Portraits & Prose

by
R. Padre Johnson

WORLD VIEW ART & PUBLISHING
Cody, Wyoming

Published by
World View Art & Publishing
P.O. Box 908
Cody, Wyoming 82414

Printed in the United States of America
through the joint effort of

Yellowstone Printing & Publishing
Cody, Wyoming
and
John Roberts Co.
Minneapolis, Minnesota

ISBN #0-9635277-0-3
Library of Congress Catalog No. 92-091133

Second Printing

DEDICATED TO

My Wonderful Parents Ray and Lorena Johnson

You nurtured my life with an unusual expression of unconditional love. You were always there to encourage and to affirm my growth as a human being. As far back as I can remember you encouraged me to draw and to stretch my curious mind. You allowed me to risk, to make mistakes, and to explore the higher ridges of human experience. For cultivating this sense of freedom to be my own person, for your thoughtful prayers and genuine unselfish care, I say thank you again and again, with an eternal gratitude.

To My Children, Raym and Rick and Reesie

We shared a very special love, trust, freedom and mutual respect for one another and for people of all racial, ethnic, religious and non-religious backgrounds. You were all so interestingly different, yet so very enjoyable to be around. I have always been proud to call you my children and to be your father and friend. Thanks for your warm open affection and understanding.

To My Dear Friend, Oscar Wahl

Your beautiful mind and spirit has been a joy and privilege to appreciate. Though four decades separate our ages, the common soul that has linked our experience of togetherness through the years is a treasure that is rare even among the best of friends. Through all my travels I felt your warm human spirit and your honest prayers for my safe return. Thank you Oscar, for being my eternal friend. I shall always remember the way we hug each other when we meet.

If there is one ingredient that fills the glass it is the exceptional situation humor that we all share in our own ways and with a common appreciation. These moments of laughter truly mark some of my finest memories. How we laughed!

ACKNOWLEDGEMENTS

The development of this book reflects the influence and contributions of so many thousands of people who shared their learning, understanding, encouraging spirit, prayers and kind hospitality, that to list the names would extend for pages. They are from all walks of life and from all nations. Most have given as much or more to me as I was able to give to them.

Every author is especially thankful to those who work very closely with their project. Therefore I wish to give special thanks to the people who were closely involved in the support and actual mechanics of causing this publication to become a reality.

It is my privilege to express a special gratitude to Mindy Cole, the owner of Typagraphics, who interpreted my handwriting and typed my endless drafts; to Heidi Fischer for her exceptional editorial skills; to Bill Blake and Ron Maier for their skills in the required area of professional photography; to my cartographer friend, Alex Dean, whose maps provided a clear insight into the geographical proportions of my journey; to Randy Perkins, who provided the book's design; to Carl Bechtold, the President of Yellowstone Printing and Publishing, for his close scrutiny to detail and the printing of the first phase process; to the John Roberts Company of Minneapolis, Minnesota, and to Robert Keene, Jr., and his staff for their excellence in completing the printing process; and a special note of thanks to the leadership of Shoshone National Bank in Cody, Wyoming, for their trust and their willingness to provide the necessary financial loan support to complete this project.

A special note of thanks to my family, to Oscar Wahl, and to all the others who have given their sustained support toward the realization of this project.

CONTENTS

FOREWORD

Most people dream about the opportunity to travel extensively throughout the nations of our planet. Through the written, painted and sketched interpretation of Padre's fascinating thirteen-year journey with the people of every nation on our planet, we are given the opportunity to visually feel the wonder of our common humanity.

In Padre's written impressions and in the global faces he has sketched and painted with such an unusual quality of aliveness, he has succeeded in giving scope and depth to the sense of oneness of our global humanity. Through his thoughts and renderings of the various shapes, textures, colors and moods of the human face, he has also reminded us of the fact that the human aesthetic transcends geography, culture and all the artificial impediments that divide and erode our genuine respect for what makes us truly human.

Portrait art is a unique creative expression. In Padre's renditions of the people he lived with, he reveals something very positive about himself, his reverence for life, his unique global insights and many of the human truths that evolve from his life experiences with our global family. The true value of Padre's ambassadorship could only be realized through his careful listening and a natural sharing of his open human soul, acceptance, compassion, humor and appreciation for the interesting differences and enjoyable similarities of our human family. This is a family that in Padre's words, "gave as much, if not more, to me, than I gave to them."

Openness in the features of Padre's portrait renditions is a very important concept for the reader and viewer to consider. It is the expression of the open child in the face of the person that has crossed Padre's path which allows for the most enjoyable and meaningful communication, whether of the same, similar or different race, creed or nationality. It is this mark of openness which Padre frequently refers to that helps to dismantle many of the restrictions and prejudices that so often prevent cooperative human efforts from realizing effective human and natural environment solutions for the people and nations of our planet earth.

The representative selection of sketches, paintings and thoughts in this book suggests why it is critical for all societies, races, political and religious divisions of our human family to come together and listen and then perhaps to appreciate our important diversities and similarities. Only then can we expand the type of understanding that will help to openly address key global issues and truly implement actions which will benefit all members of the global family.

As we move through the approaching years of rapid global change, I believe the substantive quality of this book and Padre's exceptional ability to translate his insights into the human family to canvas and paper will not only leave an enduring mark on the consciousness of each reader and viewer, but will also maintain a very unique historical significance.

At the United Nations, we are endeavoring to give more and more attention to the arts to assist our efforts to infuse new vision into our sense of caring for the earth and its human family. Within this framework, I am confident that the open humanness and insights in this work will make a significant visual contribution toward increased international understanding, peace and good will and also assist many individuals and institutions to cross the threshold of the twenty-first century with a higher sense of confidence in a realistic but positive future for all our global citizens.

Dr. Noel J. Brown, Director
United Nations Environment Programme

INTRODUCTION

AN INSIGHT INTO MY FASCINATING JOURNEY WITH THE GLOBAL HUMAN FAMILY

By R. Padre Johnson

You are about to embark on a visual history involving my adventure with the people of every nation on our planet earth. This also includes the very meaningful experience of living with an interesting range of tribes and villages across our world that still function in the ways of their ancestral past.

My sincere hope for this publication is that it will help readers of differing cultural, religious and political views to more clearly understand, appreciate and respect the innate value of each person nurtured on a different plot of ground and with a different set of religious and cultural values. Within this context of openness, I also seek to stimulate a new appreciation for the threads of commonality that draw all citizens of this planet more closely together as one global human family.

This writing reveals my personal observations, concerns and insights regarding my reverence for human life and the inherent worth of all living creatures. My respect for the personhood of all people undergirds my thoughts about the freedom of the human spirit, the physical care of people, world peace and the high priority I give to environmental concerns. All are of equal importance! All are inseparably linked in a common search to balance human needs and environmental health in the approaching decades of life on this planet.

Life Transformed into Art: A Biographical History

As long as I can remember, my parents and grandparents encouraged me to risk and explore new frontiers of knowledge and understanding. My native urge to scale the higher ridge of the unknown became as natural an exercise as my daily routine of physical exercise. This freedom to explore all levels of my own humanity and the common humanity I enjoyed in others, even those classified as unacceptable, made me realize that the only way to improve my understanding and appreciation of other people and cultures was to stretch beyond the comfort of my own boundaries to share their thinking and their feelings.

The material for this book has been influenced from these early adventures, from thousands of pages of observations maintained in my personal journals between 1962-1992 and from files of classroom notes at various levels of my academic career.

My first journal entries record my experiences as a community/campus pastor in Vermont and New Hampshire, a hospital and prison chaplain in the Sixth Naval District, and then in 1967-68 as a twice-wounded special-forces medical chaplain in Vietnam's Mekong Delta.

The next phase of my journal observations is taken from a time frame following my departure from the active ministry of my denomination, the Lutheran Church in America. This involved an extended period of fulfilling leadership positions in human services at national, state and local levels. It was during this period that I developed a very close working relationship with many Native American Indian communities throughout the United States and Canada. At National

Technical Services Foundation I served with a multiracial staff as its community development director. At NTSF I assisted socially and economically disadvantaged low-income minority communities in the development of effective self-help enterprises and projects. During this period of change, I experienced the unique opportunity of serving as director of development for the Governor's Crime Commission in the state of Minnesota. There I designed and helped implement a number of successful experimental community-based crime prevention and corrections programs.

In 1974, a new element of change in my life's journey occurred when I returned to the institutional church as resident minister in an ecumenical "new town" community church experiment outside Minneapolis, Minnesota. This ministry to a wide range of religious and non-religious persuasions was sponsored by the National Council, Minnesota Council of Churches and the Lutheran Church in America. During this period, I also began my doctoral studies in the combined fields of ministry/theology and cultural anthropology. The research for my thesis brought me to eight religiously and culturally different societies across our globe.

Ironically, my doctoral research provided the introductory material and motivation in completing my research and portraits for my global project on "The Face of the Human Family". Because my personal world view in my research was considered controversial by some influential church authorities, I decided to once again depart the active ministry and return to the state of Wyoming where I worked as a hired hand on several high-country ranches, including one of the last horse-drawn chuck-wagon outfits in the American West. Here I worked and lived with a vanishing breed — the American cowboy. One day during this sabbatical ranching period, I traded my cowboss a portrait sketch for one of his favorite saddles. That sketch later came to the attention of the director at a local art center, and my professional art career was born.

After receiving some high-profile awards and increasing attention from leading collectors, my western wildlife and commissioned portraits began to command higher and higher prices. Soon I found myself refocusing my priorities, which triggered a renewed interest in the global family. The decision to expand upon the journey I had initiated in my earlier doctoral research seemed both natural and right. The timing was right, and now I also possessed the necessary income to independently fund the research for this larger-than-life global project.

As I write my thoughts and impressions for this global portrait presentation, I am deeply thankful for the unusual and diverse life events and experiences that have shaped my personal history. Without this background diversity, I don't believe I would have been able to listen, see and translate my impressions of our global family's open-faced soul with quite the same insights.

After years of separation, I enjoyed a very special meal one evening with my former history professor following my second visit to the Melanesian and Polynesian islands of the South Pacific. After an extended period of silence at one point in the evening, my professor relayed a very important insight which, in my clearest recall, I immediately jotted down when we separated. "Padre," he said, "your native instincts and lust for exploration can only take you so far into the process of a quality interpretation of your subject matter. Without the range of your unusual life-tested events, influences and the diversity of the secular and pastor/priest-related jobs shaping the interpretive process of your life, the focus of this project would never have reached quite the same global/human definition of truth." He then reminded me of the invaluable role that my previous pursuits had contributed in helping to refine the process I utilized to interpret my global concept for the readers and viewers of this project. He pointed to both undergraduate and advanced studies in the disciplines of world history, philosophy, psychology, theology, comparative religion and to my lifelong fascination with the study of anthropology, specifically the field of cultural anthropology.

As we continued our discussion, he mentioned the invaluable practical experience gained as a city hospital emergency-room technician and later as a field medical chaplain in Vietnam. These skills prepared me to provide medical assistance in numerous emergency situations all across our planet. In some tribes and villages the gestures of thanksgiving I received for helping in a moment of need were overwhelming. My medical experience has certainly been a helpful factor in often initiating a level of openness, respect and acceptance that wouldn't have been possible in certain situations without medical intervention. In retrospect, all the positive, and even negative pieces in my journey have a purpose in shaping my global views and insights.

My Global Journey

During my more than thirteen years of accumulated research into the open face of humanity, I've had to seriously immerse myself in a free-spirited, but very intense study of the racial, ethnic and facial features that mark the diverse cultural landscape of our planet. The more I explored the human family, the more I appreciated both the interesting features that are unique to each individual and the limitless threads of similarity which clothe each global citizen and also link each person to his/her common indigenous heritage.

During the process of my adventure with the people of this planet, I discovered in each new face the uniquely sculpted blend of race, culture and ethnicity reflecting pleasure, love, fear, pain, happiness, anger, among all the other emotions common to all of us.

Central to my creative process has been the ability to listen, observe, feel, enjoy, laugh and appreciate the cultural tastes of almost every racial, ethnic and cultural group on our revolving globe. Of the world's 179 sovereign nations as of this writing, I have crossed the borders of 139 (returning two or more times to many) to enjoy open and thoughtful conversation, laughter and food with many of its citizens. Without exception, I always met people from some of the other nations I did not have the opportunity to visit. This usually occurred when I traveled in one of their neighboring countries. For example, though I have never traveled to Cuba, I've experienced the personal enjoyment of meeting and conversing with hundreds of recent Cuban immigrants and families in the United States, as well as in other locations across our global turf. Though I have never been to Uganda, I've shared conversation, laughter, food and friendship with many Ugandans in Kenya, Tanzania and beyond.

I have also crisscrossed the cities, towns, farms, ranches, and back roads of all fifty states and territories of the United States, Canada and Mexico throughout the past thirty years to listen, observe and participate in the diverse emotional and cultural fabric of this amazing North American continent. During my life I've also had residence in eight distinctly different regions throughout the United States.

In order to reach this planet of vast racial and cultural diversity, I've traveled by almost every means of available transportation. This includes Amazon and various African dugout canoes, Alaskan and Canadian Innuit kayaks, Aegean fishing boats, sailing vessels, ships, air transport of every size, shape and condition, air balloons, jeeps, cars, trucks, Land Rovers, buses, dogsleds, river barges, junks, rickshaws, elephants, camels, mules, yaks, donkeys, horses, bicycles, motorcycles and thousands of miles on foot. To say the least, it's been one incredible traveling adventure!

My sleeping quarters with city and small-town folk, country farmers, indigenous tribes and nomadic herdspeople include mission houses, hostels, mountain cabins, motels and hotels of every condition and price level, native tents, huts, yurts, and trains of various quality and motion. I was the invited guest in hundreds of local houses and slept on bedrolls under the

open stars with such nomadic peoples as the Bushmen of the southern African Kalahari and the shepherds tending their flocks on the hills outside Bethlehem in Palestine. Enough.

How I survived the diverse menu of cultural foods without any serious forms of indigestion will always remain a mystery to me. I must certainly have been granted some unusual other-worldly protection, or perhaps just enjoyed the good fortune of an inherited immunity. I've welcomed most all of the cultural foods I've eaten over the past twenty-five years as a tasty adventure offered by a hospitable host and hostess. Eating together provides time for people to come together. It also provides the best opportunity for meaningful dialogue between friends and strangers. When you're invited to share a meal with people anywhere on this planet, you are also invited to participate in the openness of their soul. When you eat together with friends or the stranger from a foreign land, you almost always share open laughter, situation humor and the enjoyment of storytelling. In all societies, both simple and complex, eating is the primary activity for initiating and maintaining human relationships. It almost always provides an appreciation of a person from a similar or vastly different race, culture or social structure.

As my journey has evolved, I have enjoyed the good fortune of sharing meaningful thoughts, feelings and humor with people from so many different walks of life. The range involves full-time working mothers in every society, teachers, farmers, royalty, social workers, ranchers, politicians, nurses, the unemployed, the homeless, doctors, attorneys, artists, scientists, tribal chieftains, shopkeepers, professional athletes, students, people in the military, peasants and journalists, to name a few. Yet as I contemplate the many people who have crossed my path and stimulated new layers of learning in my patterns of intellectual and emotional growth, I have to admit that I've frequently learned as much, if not more, about the simple meaning of our human existence from the uncluttered intellect, awareness and understanding of the indigenous tribes and nomadic herdspeople than from most of the elite technical minds within the academic institutions and ranking corporations of our world's industrialized societies.

An Important Event in My Learning Process

In October 1991, I crossed back over the Afghanistan border at sunset into the safety of Pakistan's Northwest Frontier Province. At that moment, the force of an emotional rush literally commanded the attention of all my senses. As we stopped for one last lingering contemplative view into the memory of a most incredible journey with the fiercely independent Mujaheddin tribespeople of that free-spirited majestic and mystical land, I felt the warmth of an unusual fulfillment of mind and spirit. I was now satisfied in knowing that the last chapter in my research project was complete.

As I wrote in my journal about the Afghan people and their cousins in Pakistan's border province (people I have dreamed about since my early teens), I realized once again that no race, ethnic or religious group possesses a superior awareness or intelligence over any other on this microdot earth in the limitless space of our universe. With only different modes and levels of opportunity, we are all children of a common family, learning through a similar preschool curriculum the expressions of living and giving.

From my global perspective, no one person or group of people has achieved a pure understanding of the centerpiece of universal truth. Therefore it seems both logical, right and humane to me that no individual or group has the right to impose a religious or cultural way of believing and living on people of differing beliefs.

The Key Point of My Book

My sincere hope is that this book will help to cultivate an understanding and openness toward every color, creed and cultural practice that contributes to the beautiful and interesting balance in our common humanity. A mature spirit of openness allows us to see, appreciate and respect each person as an individual candle of human worth. A mature spirit also fosters the most inclusive communication between humans of all racial, ethnic, cultural and religious families. The risk of openness provides the key for dismantling the restrictions and prejudices that so often prevent the people and nations of our miniature life-breathing planet from realizing effective and workable solutions to our common problems.

During the course of my global journey, the open, accepting faces of people in every nation, tribe, village and city across our world have shared with me the seeds of hope for the future of our global family.

Human beings everywhere possess the same biological needs and vulnerabilities. Therefore, it is not surprising that there are many common themes between societies. All across this planet I've appreciated a common human situation humor and enjoyment of family and the family meal. I've also been a participant in their play, spats, risk, pain, dignity, the offering of respect, affection, cautiousness, childlike curiosity, thankful appreciation, acceptance, trust, excitement, happiness, joy of sharing a gift, anger, pleasure, look of love for one's child, parent and grand-parent, look of being in love, or seeing and welcoming a friend. These and many more human expressions are threaded into that eternal tapestry of the global human family, as natural expressions common to all citizens of our earth. Most of these common expressions are reflected through my hundreds of portraits in this book.

I often think, if more people could only take a few more minutes a day to appreciate the similarities and important differences in our humanity, perhaps a new seed of understanding would begin to germinate. This would have the potential of shaping a whole new process of evaluating and understanding the personhood of all members of our global family, including our nearest neighbor of the same color and cultural heritage. Where there is an openness to listen and learn, there is no need to enforce one's views or control the response of another person.

Throughout my journey, I allowed a natural, open, accepting attitude in my face and body language to flow freely. Almost without exception, I received, in kind, an equal and often a larger expression of heartfelt greeting and hospitality. When your face and eyes naturally reflect the spirit of an open acceptance and trust, which exists to various degrees in almost every person I've met, including the so-called hardened prisoners I conversed with as a prison chaplain, something very exciting occurs in the field of human diplomacy. The open child in each communicant is almost always released and prejudices in various degrees are dismantled.

The beauty of an open mind and spirit in personal dialogue with someone from another culture allows you to hear different sounds, to reflect the honesty of self-respect and perhaps the natural spontaneous ability to laugh at yourself which opens so many communication possibilities and appreciation of our human equality.

No two people are ever exactly alike! Each person to walk the face of this planet is uniquely different in shape, color, facial structure, sense of awareness and personal tastes. Therefore, the value of each unique individual human fingerprint as a separate candle of human worth deserves my clear respect through the look in my eyes, the tone of my voice and the touch of my hand.

There are times when I perceive the wonder of this vast expanse of global humanity with its billions of individual souls as a fascinating mosaic which does not fuse, but links and respects the dignity and traditions in each family unit. At other moments, I picture this amazing global panorama as a vast rain forest with an unlimited blending of colorful tree, bush, plant and leaf variations. Similarly, as in the life cycle of the rain forest, each human person is also unique to his/her own form, but interdependent on other members of the human forest.

In this human forest, each member possesses a sense of morality and a system of values which are shaped by his/her religious and cultural conditioning and based on a respect for the laws of the universe. Each has a need for friendship and the affirming love and recognition of a parent, child and friend. Each has a desire in degrees to fulfill sexual needs. All these and many more interrelated features make up this rain forest of amazing colors and bodily diversities.

Some cultural anthropologists use the term multicultural to define the mixing of cultural groups within the human rain forest. Whatever aids we use to define this amazing global human family, my hope is that many of the viewers of my oil and sketched portraits will see themselves in the faces of people of another color, race or ethnicity, and thereby feel and express a deeper sensitivity for the value, dignity and intrinsic worth of all other living interdependent human beings in our multicultural rain forest.

Though most all of the territories I traveled to were experienced without a traveling companion, my global journey has certainly not been a lonely journey. On the contrary, it was marked with unlimited adventure and opportunities to give and receive, explore and appreciate the soul of each culture and the open, trusting character of every person with whom I played, laughed, danced, ate and shared my humanness.

The Global Family: A Philosopher's Perspective

Philosophers are commonly perceived as explorers and interpreters of the abstract meanings of human existence. From my previous studies and continuing self-education in this discipline, I've increasingly become less interested in the abstractions of academic philosophy and more intrigued by the myths and everyday storytelling that reveal a culture's values and the insight of its people into their own natural human condition and what they consider important to the real fabric of everyday living.

In my view, the seasoned philosopher is able to demonstrate the ability to both listen and tell stories that relate to a gut-level meaning of human existence. He/she also possesses the timing to tell interesting stories and reveal personal insights just for the sheer pleasure of sharing the enjoyment and humor of everyday living. The laughter that results is one of the basic ingredients in the healing of global, national and domestic human problems.

When humor, especially the luxury of self humor (laughing at one's self), flavors the human drama, something happens that literally frees one's spirit to discover the goodness in others. It's the oil that also opens the mind to trust certain conditions that may exist beyond one's physical and psychological control. A perceptive philosopher possesses and exercises the natural awareness to seek the good in other people.

Oddly enough, that sense of awareness may just as frequently reside within the consciousness of nomadic herders as in the trained academic mind, since these herders and all their counterparts across our world usually remain more uncluttered and spiritually free to appreciate such natural values as love and care of family, unconditional giving and the lust for life's enjoyment.

The Human Family: A Global Historian's Perspective

My sense of history has always served as an invaluable asset in interpreting the meaning of my global project. My study of world history has helped me to develop a continued sense of our shared humanity. It also provides a very helpful resource in understanding myself with greater clarity.

Cultivating a historical perspective serves as a very important ingredient in perceiving how people and cultures resemble and differ from each other. It provides a strategic aid in my need to grasp the complexity and cause of historical events, thus making it less likely that I will always search for simple answers and dismissive explanations. A sense of history has also assisted me to more clearly recognize the impact of political abuses on religion, culture and the role of good government throughout our world.

An Anthropologist's Perspective on the Global Human Family

My interest in history serves as a natural and important link to my fascination with the science of anthropology. My long-standing association with and continuing education in this field underlie the foundation for my entire global project.

Many of my professional colleagues agree that one of the more interesting fields in recent decades involves the study of anthropology. Its root comes from two Greek words meaning "the study of humans." Anthropologists attempt to understand human nature through research into a culture's behavior patterns. They also deal directly with the human and natural environmental conditions that adjust the process of living. This attempt at investigating and describing the different peoples of our planet, both past and present, is its primary task.

The discipline of anthropology is divided into two separate but complementary branches: biological anthropology, sometimes referred to as physical anthropology, and cultural anthropology. Those who concentrate in the area of biological anthropology research the development of the physical, skeletal and genetic makeup and characteristics of humans primarily through fossilized remains. Cultural anthropologists study lifestyles among both ancient and contemporary peoples. This has been my primary interest, and whenever possible I like to live with a society and observe its ways of living (doing and being) at close range.

My interest in cultural anthropology overlaps with other fields I have always found fascinating: sociology, geography and archaeology. My studies in cultural anthropology have helped me to recognize and present the similarities and differences that make up the fascinating colors and anatomical designs in our global human tapestry. Ideally it teaches the serious student to understand and accept the ways in which different societies interpret life. To the open-minded student, what may seem irrational, senseless or even immoral at first observation is accepted, logical and useful to the society under study.

As the student continues to listen, watch and learn from the society he/she is closely observing and enjoying, an appreciation and respect develop for the intrinsic values and differences in all other cultures, as well as a deeper appreciation for his/her own cultural roots. For example, the term primitive often used by industrialized people to describe a native culture they do not understand, will acquire a new and elevated definition. Perhaps now the new student of anthropology will choose to use "interestingly different" to describe native cultures out of respect for the interesting differences in their perspectives on time, space, freedom and their natural ways of doing and being.

Most people have real difficulties understanding the range of cultural behaviors. This is only natural since our judgments of others are influenced by the customs of our own familiar culture. Consequently, it's very easy for us to almost unconsciously regard others as foreigners, believing our ways of thinking and doing are superior, or at least better.

There are many similarities and important differences that shape the index of cultures on our life-sustaining planet. Where and how a specific culture developed are influenced by unavoidable environmental factors, such as climate and terrain. Every human being is conditioned by the cultural, territorial and climatic circumstances in which he/she is born.

Culture is a term many anthropologists either move about like a pawn in a chess game or revere like a sacred liturgy. Its definitions are almost as numerous as there are authors of books on the subject. Therefore, for the purpose of this book, I'll exercise the privilege of my authorship and condense a series of definitions into my own words.

One interpretation from my journal notes views culture as the design of societal objects, ideas, traits and ways of doing and being which shapes the functions, ceremonies, rituals and beliefs of the everyday life of a community. It may also be defined as the sum of things people do as a result of being taught from generation to generation within the framework of their own family and community-based system of rules and behavior patterns. Perhaps the simplest way for me to define culture is to see it as the way of life shared by a group of people which demonstrate their sense of identity.

Another way we might interpret culture is to define it as elements of knowledge shared by members of a community, which assist them to communicate and pursue common activities. The acquisition of culture is a process that involves the fabric of everyday life, family, and ceremonial rituals in the arts, the games we play, the foods we eat, the music that inspires our listening moments, our dance and the color of our dress. Culture may also be defined as the interlocking patterns of behavior of a group of people with a plan for living which allows their society to efficiently fulfill their needs.

Another condensed perspective views culture as a set of procedures by which a community of people conduct their lives. Every element of living is integrated with other elements so that the whole forms a unit as functional as a cell in a living organism. Yet, because cultures tend to borrow from each other, they also change with the passage of time. Therefore, you can almost always say that one culture never perfectly retains the ways of its ancestors.

Each time I recall and rethink on paper the cultural values and behavioral structures of each society I've had the privilege of touching for a very special moment, I'm impressed with the fact that every culture undergoes a slow, almost imperceptible, fluctuating change as new cultural ways invade and restyle the established ones. I have personally observed this process of change in everything from carvings, ceremonial and traditional foods and dances to the myriad of other rituals I've participated in all across the planet.

From the beginning of recorded history, the cyclical invasions and migrations of people and the legacy of trade have stimulated the merging of cultural forms. Sometimes the process of change is wrenching; at other times the transition is smoother.

As we move toward the unpredictability of our twenty-first century, it will become an increasingly difficult task for stable cultures to maintain their identity, especially considering the speed at which the products of the western world are advanced. Realistically, it is almost impossible to prevent more traditional cultures from being absorbed into the materialistic glitter of high-tech cultures. In addition, it's extremely difficult for most westerners to take the time to listen and also appreciate the importance of preserving their values. We tend so easily and almost uncon-

sciously to impose our value systems on those who do not possess the size and competing technology to resist.

In this approaching new century, change is inevitable. Once-opposing nations will sign alliances of friendship, and those that were once territorial and global allies will find new uncomfortable differences fracturing their previous union. But in time, the unpredictable, but inevitable, slow-moving process of historical change will bring those opposing forces back together in a new spirit of sharing their newly acquired cultural values, instincts and customs (habits) on the newly reshaped cultural-exchange landscape of the twenty-first century.

Though this cultural overlapping will continue to occur through the misfortunes of war, invasions and territorial and global cultural exchanges, the human faces I've recorded for this project represent every century in recorded history. They are the faces I've always known. They are the faces of my past, my present and future global family. Yet as I pen many of the insights for this book, there remains a sadness in my soul as I helplessly watch the winds of change slowly erode the fresh, uncluttered natural beauty of many of the open-souled, indigenous societies I touched and appreciated through my twenty-five years of global traveling. It is a misfortune that is impossible for me to adequately translate. Even now, as my next thoughts are being formed, particles of our world's national, tribal, ethnic diversity and cultural uniqueness are passing into the archives of our memories, only to reappear during festivals. But that is a reality that we must live with as we attempt to keep alive the soul and health of our traditions of color, clothing ornamentations and cultural rituals which mark the past in the historical present. Thankfully, the ceremonial festival re-creations of the past maintain the uniqueness and record of the history of each culture which refuses to be completely swept away by the titanic waves of technological change.

Regardless of the changing cultural and social patterns of the future, the portraits of my representative global experiences reflect the openness that will continue to appear in every face from generation to generation. Some of the faces I've recorded for the historical record come from travels during the late 1960s. Some come from the eight separate cultures, religious persuasions and geographical territories I studied during my doctoral research in the 1970s. Most of the faces come from my most recent travels between 1982-1992.

Some of the faces recorded on my composite portrait canvases present a style of traditional dress that may have changed slightly or even dramatically since I enjoyed contact with that person. Each image also resembles the basic facial features of the subject's ancestral past as well as the expression and composition of a face in our global future. In either place, the faces I've selected reflect the person's culture and the qualities and expressions he/she shares with members of other races, nationalities, cultures and religions.

The Racial Divisions and Subclassifications of the Global Human Family

When most people attempt to interpret the meaning of anthropology, they tend to think of a group of scientists pursuing the study of race, genetic traits and the classifications and variations among races and their descendants within the human species.

The following definition of genetics merges a variety of definitions to formulate our present and future populations on this planet. Genetics is the science that helps to explain why, for example, dogs reproduce dogs, and why and which inherited traits occur in the breeding populations of our planet earth. It also researches the blueprint of instructions for the basic structure of all organisms and the traits contained in the heredity units defined as genes. The laws of

genetics are based on the organization of these units, which places genes into complexes defined as chromosomes. Genes and groups of genes specify such characteristics as eye color, body color, height and whether a particular species will have four legs and a tail, or two legs and a pair of hands. Different kinds of organisms also present different kinds and numbers of genes.

Most anthropologists agree that human beings originated on or near the African continent and slowly migrated throughout the world. This would mean that all people living on today's planet are in one sense related to one another. They also observe that groups of people living in certain regions for thousands of years differed in appearances from those in other regions primarily because of differing environmental conditions. For example, people whose ancestors lived in Northern climates tend to show lighter skin tones. Conversely, people who lived near the equator tend more toward darker skin tones, and those whose ancestors came from territories between those environmental poles tend to blend the skin tones of the light and dark.

For many years scholars have used these differences, including variances in the color and texture of hair and the shapes and color of the eyes to classify the human family into various races. Yet what remains confusing to some is that people assigned to the same racial groupings and even within the same family unit display widely differing features including hair and lip style. Skin color also varies widely within each racial group to where the color of some assigned to the European geographical race may reflect the same skin color as some assigned to the African geographical race. It is this reason that many anthropologists and biologists are moving away from racial labels with its potential for racial misunderstanding and discrimination and are attempting to learn more about human diversity by studying how human traits vary on a global scale. There is a growing consensus that this pursuit provides a more productive result.

This new emphasis has helped to clarify the confusion some people have with the distinction between race and that of ethnicity or nationality. In my travels I've heard people identified as members of the Jewish race or the Arab race, etc., when actually these labels refer to ethnic and nationality groupings based on certain cultural, religious and geographical characteristics. They have no relationship to a biological concept of race.

Though there are many overlapping abstract theories being formulated in today's anthropological arena, most anthropologists still utilize, with variations, the following racial classifications whose people I have recorded in my paintings and sketches of our global human landscape.

A. **The Mongoloids** (Yellow Persons)

Their skin color ranges from a yellowish cream to various shades of brown. In this group, as in so many other groupings, anthropologists tend to make approximate correlations between the latitude in which people live and the color of their skin. The lighter-skinned Mongoloids tend to exist in the northern climates of the Asia continent, while the darker-skinned groups exist closer to the tropics. Intensive research into this segment of the racial structure and color chart of the human family has encouraged some leading anthropologists and population geneticists to suggest that the Mongoloid classification, like their other global race counterparts, is more clearly understood through the following distribution of their territorial subdivisions. As previously indicated, there is also a very noticeable cross melting of all population subdivisions in the following classifications.

The five groupings that most anthropologists agree upon are:

1. The northern populations of north-central China and Manchuria.

2. The classic Mongoloid of Siberia, Mongolia, Korea and Japan.

3. The southeast Asian of South China, Thailand, Vietnam, Burma and Indonesia.

4. The Tibetan of Tibet.

5. The Innuit (Eskimos) of Alaska, Canada and Greenland, and the indigenous populations of North, South and Central America.

B. **The Caucasoids**

Although most people tend to equate Caucasoid (Caucasian) with white people, students of anthropology subscribe to a more inclusive definition. In the Caucasoid grouping, as in the Mongoloid, one experiences a wide range of skin colors. They vary from the very pale, almost alabaster, white of the Scandinavians and the Mediterranean tan of most Greeks to the various shades of brown in most Arabs. Similarly, the eye color among the Caucasoid ranges from the blues common to most Scandinavians to the dark brown characteristic among Greeks and Arabs. The hair color of the Caucasoids varies from blond and auburn to brown and black. It is usually either straight or wavy. There is also a wide variation in the structure of the nose and lips, though the width of the lip formation usually remains medium to thin. Most of the males can also grow heavy beards and large amounts of body hair and exhibit a tendency for early baldness and graying. In Caucasoids you find a wide range in height, from the medium-short stature of Mediterranean populations to the taller northwest Europeans. According to many authorities, the Caucasoids are also divided with noticeable overlapping into the following subdivisions.

1. The Northwest Europeans of Scandinavia, the Netherlands, Germany, Austria and the British Isles.

2. The Northeast Europeans of Russia, Poland, Hungary and adjoining populations.

3. The populations in the Alpine territories of France, Switzerland, northern Italy, the old Balkan territories of Romania, Bulgaria, Yugoslavia and Albania.

4. The Mediterranean peoples, including Arabia, Turkey, Iran, Afghanistan and much of Pakistan.

C. **The Negroids** (The Black Race)

The Negroid race is usually identified by both skin and hair color that ranges from between a near black to various browns. The hair is often tightly curled, though sometimes more loosely waved. The body hair is more sparsely distributed than with most Caucasoids. The lips are fuller, the nose broader. Negroids are generally longer limbed with larger hands and feet than Mongoloids or Caucasoids of the same body heights. They also demonstrate a wider variation in height than the

Mongoloid or Caucasoid, ranging from the towering seven-foot African Watusi to the Pygmies of the equatorial African rain forest. Similar to the Mongoloids and Caucasoids, there are many obvious overlappings in the following subdivisions:

1. The North American black. Even though a majority of the black population's genes comes from African black populations, it contains a significant percentage (studies average approximately 25 percent) of the Caucasoid genes from the encounter with Europeans and later Americans. There is only a very small percentage of Native American Indian in the North American black.

2. The South American and Caribbean black. Like the North American black, they have a genetic background that is predominantly African black, but with a significant percentage of European and South American Indian diversity.

3. The Sub-Saharan African category includes numerous subdivisions:

 a. Those who live in or near the west coast of Africa and the old Congo region (now the area around Zaire).

 b. Those in and around Mozambique, Angola, South Africa and lower East Africa.

 c. The East African black in Kenya, Tanzania, parts of Ethiopia and the Sudan area.

 d. The rain forest pygmy of equatorial Africa.

 e. The Hottentots of South Africa and the aboriginal Bushmen of the Kalahari, referred to by some anthropologists as a disappearing race of Capoids.

D. **The Peoples of the Indian Subcontinent**

This racial group extends from India to Pakistan, including the islands of Sri Lanka (formerly Ceylon) and Bangladesh.

Though not as widely dispersed as the Caucasoids, Mongoloids and the Negroids, the diverse population of this subcontinent comprises more than eight hundred million people. Following the Mongoloid and Caucasoid races, this grouping is collectively the third most populated race. Their skin color varies from a light brown to a brownish black hue. Their hair is straight or wavy and black. Their eyes are brown to black. Their lips vary from thin to a medium fullness. Their cheekbones have a very distinct sculpted appearance. Though some northern Indian populations are rather tall, most are short or medium in height.

E. **The Australoids**

Most anthropologists agree that the Australoid grouping located in certain areas of Australia and New Guinea and other sections of the far western Pacific qualifies as a separate racial classification.

The Australoid population ranges in color from a black to a light brown. The hair, which can vary from tightly coiled to straight, is widely distributed across the body

of the male. Although the hair color is usually black, some Australian Aborigines have a blondish brown hair color, especially the women and children. This race is usually characterized by deep-set eyes, prominent noses and full lips. As in the Caucasoid race, the male tends to gray and bald at an early age. The male varies in height between five and six feet.

F. **Melanesians, Micronesians, Polynesians and Negritos**

From the Hawaiian Islands through the western Pacific and on into parts of the Philippine Islands lives a variety of people believed by most anthropologists to represent combinations of people from Australoid and Mongoloid races. Their skin color varies from very light brown to brownish black. They range in size from the five-foot male Negritos of New Guinea to the much taller Tahitian, Fijian and Hawaiian Islanders. They are classified by most anthropologists as:

1. The Melanesian Pacific Islanders from new Guinea to the Fiji Islands.

2. The Micronesian Islanders of the western Pacific, including the Marshall Island chain, Guam and other islands.

3. The Polynesian Islands of the central and eastern Pacific, and the cultural melting pot of the Pacific - the Hawaiian Islands.

4. The small, frizzy-haired, dark-skinned Negrito people from the Philippines to New Guinea.

Some Concluding Thoughts

The other day I talked with an anthropologist friend who also has spent many years of his life traveling abroad. He said the more he travels the more clearly he is convinced that a pure race of people is almost nonexistent in the 1990s. Among every group of people, he found physical features that show a blend of racial and ethnic characteristics. As in the historic past, so in the present this crossing of racial and ethnic boundaries is sure to continue, either through illegal invasions, intermarriage, or purely through a connection that is fueled by the intriguing fascination and sexual adventure with someone of another racial/ethnic facial feature and color. Sexual interrelations have always marked their brand on the drama of the human reproductive process. Once new genes are introduced into a population they will continue to surface through the centuries. Even though they may emerge in a weaker form each time, they nevertheless blur the rigid lines of racial purity.

When all this racial data is codified, we'll find that we possess the potential to live in racial harmony not because we are created alike, but because we share the threads of a common humanity which enable us to share a natural respect, acceptance and appreciation of those special virtues.

Most people would agree that much of our world is controlled by economic and political greed and thoughtlessness, and yet, in spite of this abrasive reality and its disregard for the welfare of people who simply desire the dignity of human respect, I continue to believe that there exists deep in the soul of every person a wellspring of goodness. In the open face of almost every global citizen I have ever met, I witnessed to a lesser or greater degree a belief in the rightness of racial harmony.

There is a light at the end of the tunnel, which is difficult, but not impossible, to reach. If the portraits of the open faces I've enjoyed could serve in just some small way to encourage one person to trust another, then my years of global investment have been worth the effort. Similarly, if just one face I've photographed, painted or sketched could serve as the lens through which a viewer is able to appreciate a brother or sister of a different color, creed or culture, then I will have fulfilled a key objective in my global project. Even more significant, if viewers pass on this acceptance to others, they make a meaningful contribution to increasing the spirit of harmony and goodwill among the global citizens of this planet.

As both a trained and self-educated historian, philosopher, anthropologist, portrait artist and global explorer, I've learned to very carefully observe and also listen to the sounds of each culture in which I had the privilege to become a participant. From the first moment I embarked on my global adventure, I was committed to extending my best effort toward interpreting the soul of our global citizenry. Only if I extended myself to the limits of this task could I complete this project as one who felt his art was truly authentic and credible.

The deeper I journeyed into the human forest, the more convinced I became that to effectively interpret the human family and truly make my work live and breathe on canvas as a credible artist, I had to personally experience the people, their ways of being human, their instincts and their sense of community and family living. I also had to risk eating everything they offered. This was the only authentic way I could successfully translate the pulse of their culture and the many emotions that spilled out of each soul.

Historically, most often it has been the artist, poet, playwright, historian and philosopher who have called humanity to stop, listen and see with a clearer focus the potential for meaningful development and peaceful harmony in our international, national, community and family relations.

Andrei Sakharov said shortly before his death in his Russian homeland: "True freedom is not merely desirable, but the indispensable ingredient in the process of human development." As the arts are to a lesser or greater degree integrated into the soul of all people, the instinct for freedom within every person also remains the pure essence of art. Because the process of freedom is so deeply connected to the artist's psyche, it is incumbent upon the authentic artist to interpret human experience visually through his/her sculpture, brushwork, sketches, dance, music or poetry.

At the 1990 Global Citizen Summit in Moscow, I served as a presenter in a list of fascinating speakers. There we exchanged ideas, concerns and solutions for problems within the human and natural global environment. In my presentation I suggested that we must give serious attention to living at peace with our world in the twenty-first century. If this is truly our leading priority, then governments on international, national, and local levels are going to have to begin to listen to what artists are saying about developing workable human and environmental restoration policies and practices for our planet. With few exceptions, such as the election of the insightful playwright Vaclav Havel to the presidency of Czechoslovakia, artists are rarely, if ever, consulted in a serious debate about our geopolitical program strategies.

In essence, it is the comparative thinking and interpretive skills of the poet, playwright, artist and historian, people with insight into the human condition and sensitive people from the most unlikely walks of life all across this planet who can most effectively influence and assist the political decision makers to stop and listen. If they choose to listen to these nonpolitical voices, then perhaps they will also decide to employ meaningful human values in designing workable solutions for our unpredictable and challenging future.

A Few Photo Memories From My Global Journey

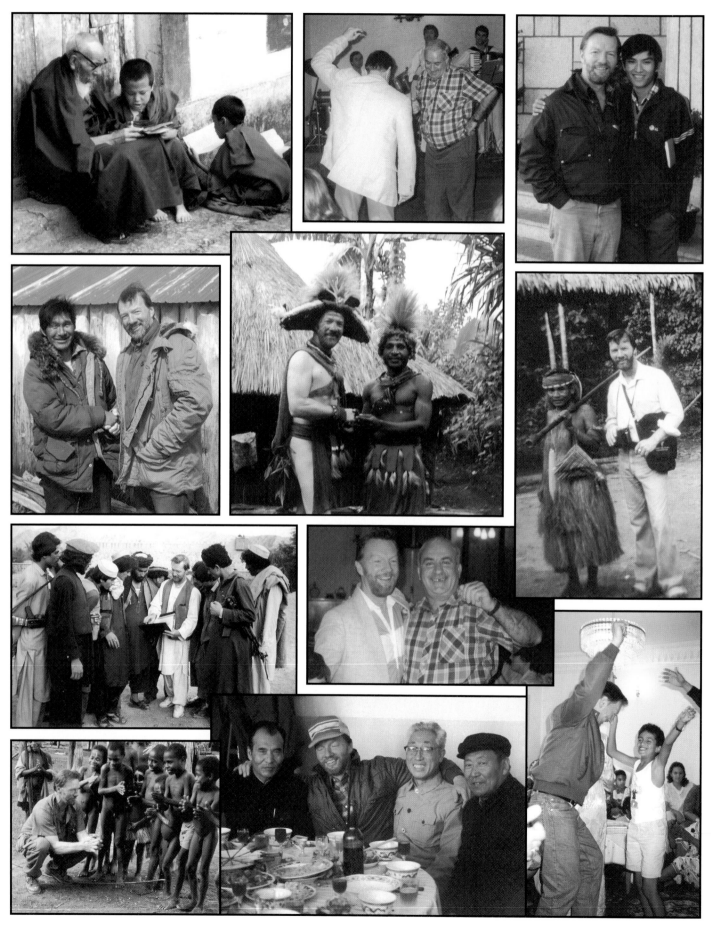

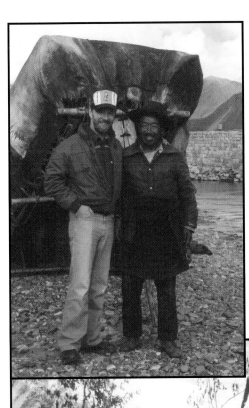

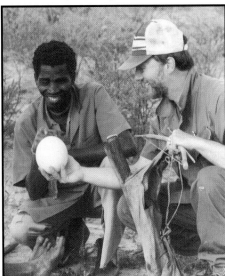

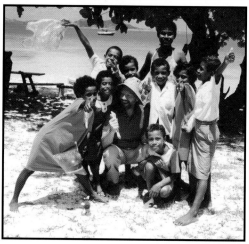

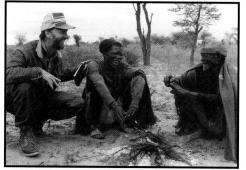

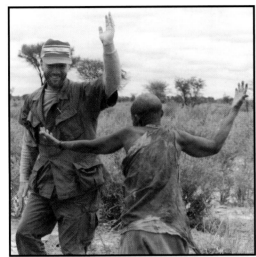

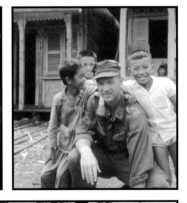

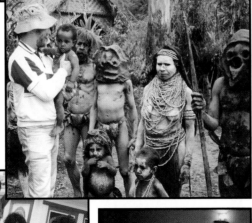
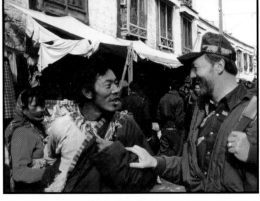
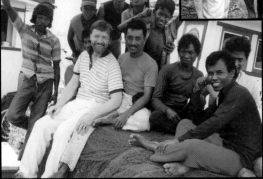
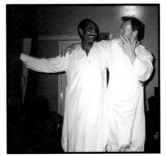
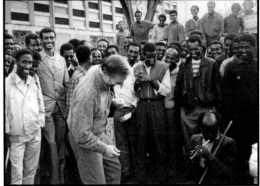

THE GLOBAL HUMAN FAMILY

This centerpiece painting provides the view of our incredible earth from outer space – surrounded by the open faces of 25 people of all ages. If you can imagine reducing the worlds population through the faces of my 25 friends in this global portrait, you would have some insight into the approximate color shape of the world as we step into the 21st Century.

In place of our present racial separations, I prefer to view, understand and respect the people of our planet's population as one global human family with millions upon millions of overlapping color combinations, facial and anatomical body structures and an amazing diversity of ethnic and cultural blends.

As a portrait artist with an easy and curious attraction to the people of our planets human drama, I have chosen to reflect in this oil rendition, the trust and acceptance of the "open child" in the faces that I both appreciated and enjoyed. Each portrait also celebrates an important visual statement about the interesting facial differences in each individual, the culture and ethnicity each represents and the limitless threads of common humanity that draw all citizens of this planet earth more closely together as one interdependent global family.

R. Padre Johnson

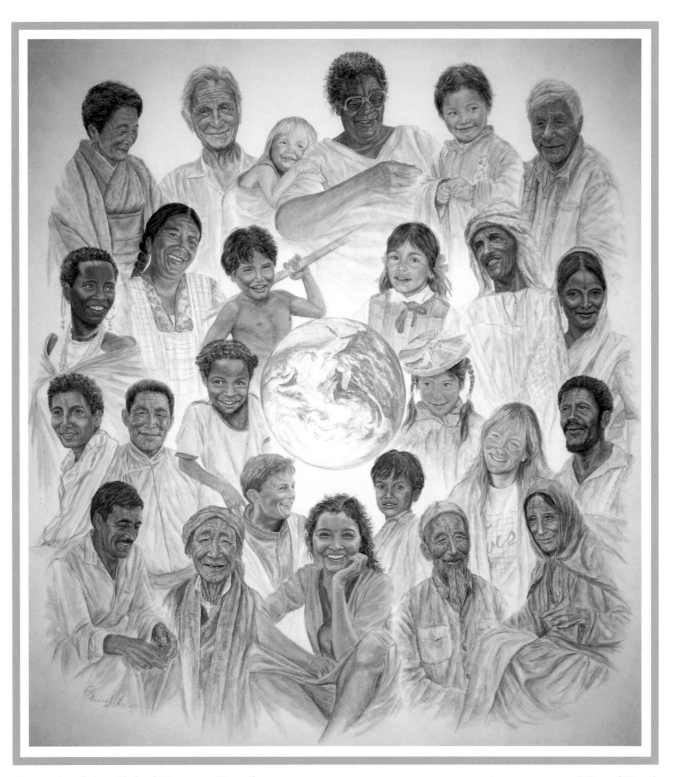

Portrait of the Global Human Family 38" x 42" oil

"Since we are all citizens of this microdot in the universe, earth, and depend upon one another and the air, water and soil systems of this unique planet for our well being, development and common survival, let us live in a way that preserves a reverence for life and gives unconditional respect to all people."

R. Padre Johnson

The following 48 page geographical journey presents over five hundred oil portraits on twenty-four major canvases representing the human diversity of the world's twenty-four geographical areas.

In most of the paintings, the place of each open face portrait corresponds approximately to the location each person lived in relation to the map representing each territory (each specific geographical area is framed on the global map).

All recent statistical information was obtained from
The Countries of the World
and their leaders yearbook 1996-97
Vol. I, II

THE CONTINENT OF AFRICA

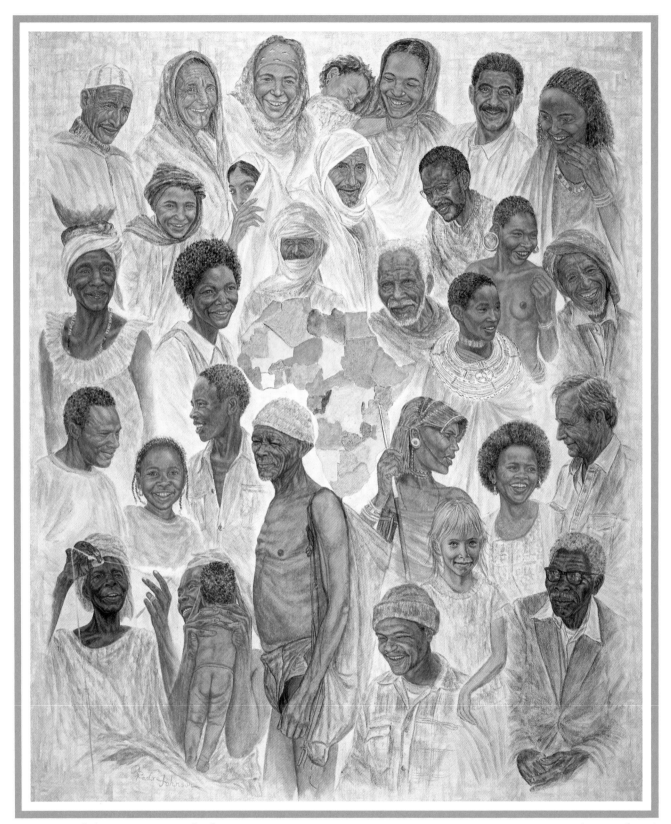

Portrait of the Continent of Africa 42" x 36" oil

"My sincere hope for this book is that it will serve to remind its readers and its author of the need to give renewed understanding and respect for the innate human value and importance of all our global citizens."

Since most anthropologists agree that the human race probably began in Africa, I chose the continent as my first painting. Africa's 11,506,000 square miles range over some of the most diverse landscapes in the world, from sand and jungle to grasslands and snow-capped mountains. Sharply rising from the fringe of coastal lowlands that ring the continent are sweeping plateaus and basins. Throughout the country these flat lands give way to mountainous terrain, from the Drakensberg Mountains at the southern tip to the spinelike highlands from Ethiopia to Zimbabwe, which claim Kilimanjaro's peaks among their dramatic beauty. One of the earth's most awe-inspiring fractures, the East African Rift slices the land, its trough cradling such lakes as Tanganyika as it makes its way to Syria and the Red Sea.

In fact, much of the geography of Africa, the world's second largest continent, is legendary. Life along the crowded banks of the 4,145 mile-long Nile continues much as it did four thousand years ago. Equally famous are the Zambezi, with its foaming Victoria Falls; the meandering Volta, where the great Akosombo Dam has created a lake with 4,500 miles of shoreline; the Niger, which rises 150 miles from the sea, traveling 2,500 miles before emptying into the Atlantic; and the Congo, with its vast hydroelectric potential.

And the continent's mysterious, inhospitable interior has piqued the imagination, from the lovers of Hollywood's Tarzan to the readers of Joseph Conrad's *Heart of Darkness*. Much of it is taken up the Sahara Desert, a great parched wilderness of which 20 percent is sand. Though forests cover only one-tenth of the continent, their equatorial heat and disease have discouraged European intruders until the last half of the nineteenth century when David Livingston's and Henry Stanley's explorations opened the interior to a rush of European colonizers.

At the conclusion of World War II, only four African countries enjoyed self-rule. Today, in one of the most extensive reshufflings of the map the world has ever seen, nearly every African country has declared independence from its foreign colonizers. Yet despite its independence, the continent's problems are immense. Comprising more than 550 million people who speak more than eight hundred languages and dialects, Africa often witnesses tribal animosities and racial and ethnic clashes that disrupt peace agreements. The ancient afflictions of illiteracy, poverty, illness, starvation and injustice plague the citizens of this land at levels that defy the imagination. Yet, its people smile and laugh, eat, make love, love their children and cherish friends and family, share warm hospitality and experience pain and suffering in ways that are common to all our global citizens.

Equally vast and complex as its problems, are Africa's accomplishments. From the time of the first pharoahs in Egypt (3,000 B.C.–332 B.C.), North Africa, for example, has seen some of the ancient world's most advanced civilizations. In 30 B.C. the region, including Egypt, Libya, Algeria, Tunisia and Morocco, was con-

quered by the Romans, becoming one of the great grain-processing centers of their empire. The Arab invasions of the seventh and eighth centuries, however, had the most lasting impact on North Africa, bequeathing to the indigenous Berbers a common language, Arabic, and religion, Islam.

In the early nineteenth and twentieth centuries, North Africa was divided between Spain, France. Italy and Britain. Though there was little intermarriage, French and English were introduced as second languages throughout the region.

The ethnic composition of Central Africa differs considerably from that of its neighboring region to the north. Comprising an area from the Sahara to the Zambezi, the midsection of Africa is home mainly to black Africans, of which the Bantu are the ethnic majority, with some South Asians (artisans who live primarily in East Africa), Arabs and Europeans.

Central Africa also is home to an interesting mix of religions. In Ethiopia and Somalia on the Horn of Africa, for example, Judaism, Christianity and Islam have mingled with indigenous beliefs to form an interesting amalgam of religious practices and customs. The Cushitic-speaking Somali trace their roots to the Cush people of the Old Testament. Ethiopia's major ethnic groups speak either Semitic or Cushitic languages, with the Semites occupying the green hills of the central highlands and the Cushitic people, mainly Muslim, living as seminomadic herders and farmers in less fertile areas.

Africa as a land of urban and wilderness extremes, aboriginal and modern lifestyles, is perhaps best illustrated by its southern region. Its citizens range from the Bushmen, who eke out a meager existence in the harsh climate of the Kalahari (represented by the hunter in the lower center of my painting) to the urbanites of modern Johannesburg in South Africa, with its wealthy high-tech industrial complex.

Until the early nineteenth century, contact between black Africans and white settlers had largely been restricted to a few missionaries and travelers. In the 1830s colonists of Dutch descent began to settle South African farmlands. Known as the "Boers," they were the forebears of the country's Afrikaner population. In time, they were joined by immigrants from England, Germany and France, whose populations helped solidify white-minority rule. Today the Afrikaners head the last white-minority government in Africa, ruling by a very tenuous thread.

What now encompasses South Africa, Namibia, Botswana, Swaziland, as well as portions of Angola, Zamba and Zimbabwe, was once home to the Koisan-speaking Aborigines. Among the descendants of these Stone Age nomadic people are the Bushmen, a short people with yellowish brown skin and Mongoloid features. They are among the vanishing peoples of the African continent who exemplified for me the best of the African spirit. They shared with me their open laughter and graciousness in ways that exceed the best definition of the word hospitality.

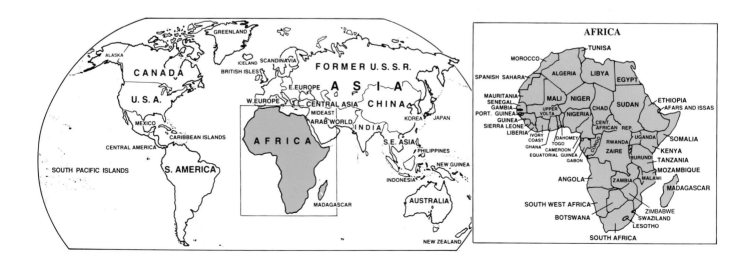

THE ARAB WORLD & ISRAEL

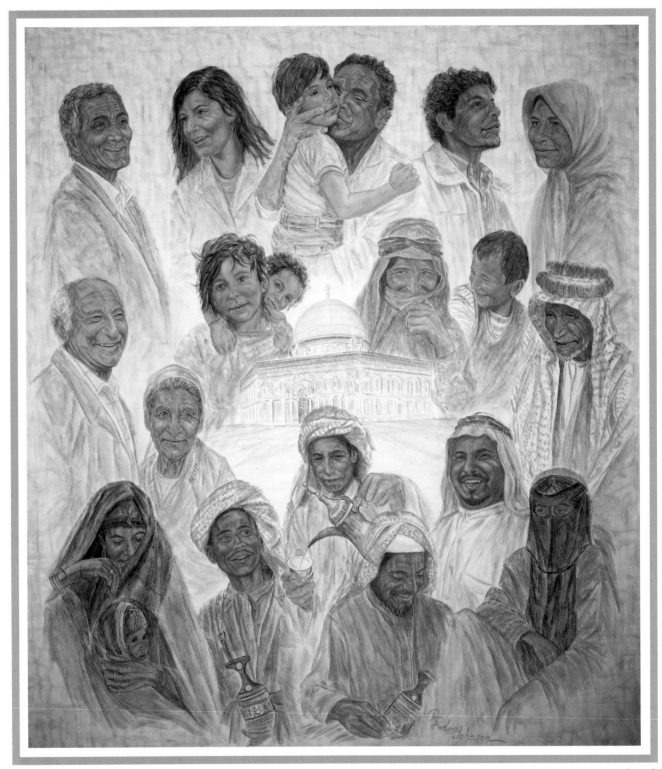

Portrait of the Arab World and Israel 30" x 34" oil

"*I have to admit that I've frequently learned as much, if not more, about the simple meaning of our human existence from the uncluttered intellect, awareness and understanding of the indigenous tribes and nomadic herdspeople than from most of the elite technical minds within the academic institutions and ranking corporations of our world's industrialized societies.*"

The Arab world (commonly known as the Middle East) truly encompasses a variety of peoples, cultures, languages, religions, ecologies and economic conditions. Since prehistoric times, this territory—dominated by the Tigris and Euphrates valley—has been a crucible of invention and the birthplace of agriculture, irrigation and writing.

The name "Arab" was originally given to the Semitic inhabitants of the Arabian Peninsula. After the death of the prophet Mohammed in A.D. 632, who founded the Islamic religion, great Arab migrations occurred all over the Middle East and North Africa to spread the word of Allah (God). Today the word Arab generally describes anyone who speaks Arabic and has a similar heritage and cultural traditions, and does not refer to a distinct ethnic group, nationality or a particular religion.

With the Arab conquests of the seventh and eighth centuries, the Arabic language attained a position of cultural dominance in Arabia and North Africa, and later throughout Central Asia. But the Arabs both influenced and were affected by the peoples they conquered, who all differed in their cultural, linguistic and social customs. Today, however, the majority of Arabs adhere to a belief in Islam as a force that unifies them as much as their loyalty to tribe and nation. Such non-Arab peoples as the Turks, Persians (Iranians), Berbers and Kurds also embrace the practice of Islam, which means "Submission to God".

In ancient times, Mesopotamia, the center of the Middle East, served as the crossroads between Europe and the Far East, it was also subject to waves of invasions and foreign domination, and has been variously ruled by the Persians, Greeks, Mongols, Tartars, Ottoman Turks, French and British.

In addition, the Arab world is the birthplace of three religions: Judaism, Christianity and Islam. Judaism's and Christianity's monotheistic beliefs helped lay the foundations for Mohammed's teachings, and the Koran—the sacred book of Islam—accepts both Old Testament figures and Jesus Christ as prophets. Five simple tenets, or pillars, remain central to Islam: faith, prayer, almsgiving, fasting and the pilgrimage. In the centuries since Mohammed's death, the use of classical Arabic and a faith in the five pillars, especially Hajj (which involves a once in a lifetime pilgrimage to the Holy City of Mecca), has functioned to bind the followers of Islam together. Today, in fact, over eight hundred million people in sixty countries from Spain and northern Africa to India, China and Indonesia are united in their belief in Islam and its practices.

In all the countries of the Arab world many religions and national minorities exist side-by-side. Syria, for example, has a strong Christian minority as does Iraq and Lebanon, communities that are composed of Greek Orthodox, Syrian Orthodox, Greek and American Catholic and various Protestant denominations. The Jewish population in Israel, too, as seen in my painting, also reflects the Middle East's significant cultural, social, linguistic and religious diversity.

Indeed, the story of Israel continues to be one of the most astonishing dramas of our time. When the Jewish state was created in 1948, it had about 800,000 people, 650,000 of whom were Jews and 150,000 Arabs. Today, the Israeli population numbers over five million with four million Jews from over one hundred nations and one million Arabs. Most Jews speak Hebrew with English often being their second or third language. From the intensely orthodox to the very liberal, modern Israel possesses a highly integrated society with stable institutions and a culture that emphasizes learning in both the arts and sciences. National security concerns also bind the Israelis together in a common cause. This sharing of the same historical and religious traditions and political and economic destinies has led to the development of a new Israeli culture, one where the old beliefs and the new ways hopefully will lead to a lasting peace between Jews and Arabs in the Holy Land.

Like the Israelis, the Kurds' struggle to survive as a people unites them. Divided by political boundaries and living in five separate nations (Turkey, Russia, Syria, Iraq and Iran), the Kurds now number over twenty million and constitute one of the largest ethnic minorities in the world. Like the majority of their neighbors, most Kurds are Sunnis, or moderate Muslims, who speak one Indo-European dialect or another and live in mountainous regions as agriculturalists.

Half the Arab world's farms harvests the fertile crescent formed by the Tigris and Euphrates rivers that extends from the Nile valley through Israel, Jordan, Lebanon, Syria and Iraq. The other cash crop of the Middle East is oil. The discovery of oil in the region, coupled with the strategic commercial importance of the Suez Canal, has put the Arab world into the international limelight and made it the focus of rivalries between the great Western powers. Oil has also given the Middle East its great wealth, for all Arab countries except Yemen have shared in the economic power and riches offered by the oil industry. Likewise, the money and opportunities created by the oil companies have enticed many Arabs to move from the countryside to the cities. Changes have occurred so quickly in some parts of the region that old customs and new have become intermingled in a way unique to the modern world.

But despite the increasing modernization and computerization of the Arab world, the old ways continue to be practiced by the nomadic Bedouins, who live in tents and enjoy a pastoral existence as sheep and goat herders. Indeed, some of my happiest moments were spent with the Bedouin peoples of Arabia in the Sinai. In every way, their generous hospitality more than matches their reputation. For no traveler in the desert can pass even the poorest tent without being invited to stop and rest, and it would be considered an insult to refuse. A long, elaborate coffee or tea celebration follows, like the one given me by the Jordanian Bedouins. Pleasant conversation accompanies the meal, and the guest is always urged to stay at least one night. By eating the food of the host, one is "eating his salt," and a special prayer to protect the traveler during the journey concludes the festivities. Such hospitality remains both the duty and the joy of the Bedouin and is a reminder that the ancient traditions of the Middle East still live on in the hearts and deeds of modern Arabs.

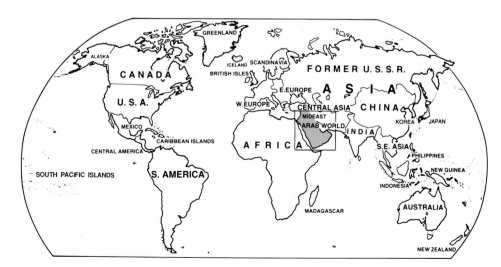

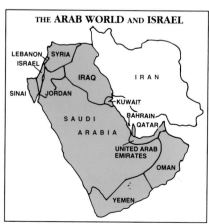

THE **ARAB WORLD** AND **ISRAEL**

THE ISLAMIC NORTHERN TIER
Turkey, Iran, Afghanistan, Pakistan

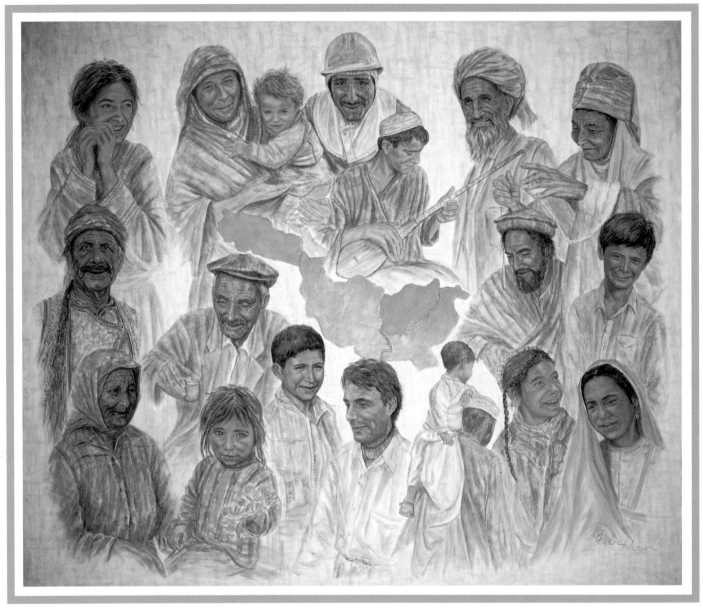

Portrait of Turkey, Iran, Afghanistan, Pakistan

30" x 36" oil

"As I wrote in my journal about the Afghan people and their cousins in Pakistan's border province (people I have dreamed about since my early teens), I realized once again that no race, ethnic or religious group possesses a superior awareness or intelligence over any other on this microdot earth in the limitless space of our universe. With only different modes and levels of opportunity, we are all children of a common family, learning through a similar preschool curriculum the expressions of living and giving."

Turkey, Iran, Afghanistan and Pakistan, known as the countries of the Islamic Northern Tier, form the non-Arab countries of the Islamic Middle East. Although this region has served as a crossroads since the earliest migrations and has absorbed a complex mixture of cultures, each country has maintained to this day a distinctive character of its own.

Among the most momentous in the region's long history of invasions and empires were the entry of the Arabs from the south, who introduced Islam in the seventh and eighth centuries, and the Turkish tribes from the northwest in the eleventh century, whose Islamic politics dominated the entire area until the sixteenth century. Supplanting Christianity and Buddhism, Islam imposed a degree of uniformity in culture and religion, although native traditions have persisted throughout all four countries.

With the Turks came two major nomadic cultures, the Central Asian tribes with their round, white, felt-covered tents and two-humped camels and the Middle Eastern nomads with their rectangular, black-goat-hair tents and one-humped dromedary camels. After the rise of the Great Ottoman Empire and the fall of Constantinople (now Istanbul) in 1453, Turkish and its many dialects became the main language in much of the area.

The region's history is long, inspiring and often troubled. Afghanistan's strategic position, for example, has proved irresistible to aggressors from Genghis Khan to the modern-day Soviets. In Pakistan, thousands of years of history predate the arrival of Islam in the eight century. The earliest of the world's four great cradles of civilization arose here along the banks of the Indus River. Alexander the Great crossed deserts and mountains from Europe to conquer and occupy the land. Since then many invaders have come and gone. In 711 A.D. Muslim Arabs arrived on Pakistani shores carrying the new faith of Islam, leaving a lasting mark on the religious and social life of generations to this day. The last of Pakistan's occupiers—the British—relinquished their claims in 1947, when India declared its independence from Great Britain.

Today these migrations, largely for political and economic reasons, continue. Iran, one of the world's large-scale producers of oil, has seen an influx of workers from Afghanistan. Following the 1979 overthrow of the Shah of Iran by Islamic fundamentalists, many middle-class Iranians fled to Europe and the United States. During the Soviet occupation of Afghanistan, more than two million Afghans escaped to Pakistan and Iran. Afghan laborers have also left their country in search of work in Iran and the Persian Gulf countries. And Turkish workers have migrated to Europe and the Arab oil states.

Although modernization has made increasing inroads into Western Asia, the culture continues to be dominated by rural and seminomadic tribal societies. Throughout all the northern tier countries, the majority of people still earn their a living as farmers or herders.

Whether nomads or villagers, townspeople or urban dwellers, most people of the northern tier settle near water, usually where the foothills meet the plains to take advantage of snowmelts from the heavy winter snowfalls in the mountains. Along the rivers, settlements form a linear pattern, in which villages are strung out like beads on a necklace.

Because of its relative isolation, each settlement retains many of the local building materials and customs of the past. As you move from the plains to the mountains, stone replaces mud brick as the building material of choice. In more forested regions, such as eastern Afghanistan, the people build more complicated wooden, multistory houses. The nomads still herd in some areas as their ancestors did, many living in goat-hair tents or yurts, which are popular in northern Afghanistan, Pakistan and northeastern Iran.

Nomads and villagers alike rely on the town market for services and the circulation of goods. Handicrafts, raw materials and agricultural products are transported via donkeys, horse-drawn carts, camels or are carried on the backs of the villagers themselves. Because telephone lines often do not extend beyond the towns into the countrysides, tea houses double as local news gathering places.

While village life continues much as it always has, the cities are growing rapidly. Often villagers and nomads come to the city in the off season looking for work in industry, returning to their homes when the planting or herding season begins. For those who stay, urban life often offers only meager rewards. Most villagers still prefer as little contact with the city and its governing authority as possible, particularly the older ones.

While most citizens of the northern tier are farmers and herders who live close to the land, they are also unified through race and religion. Today 95 percent of Iranians are Islamic fundamentalists, while most of Turkey, Pakistan and Afghanistan are of the more moderate Sunni influence of Islam.

Most of these people are also Caucasian, though traces of the Mongoloid race appear in some nomadic enclaves in Afghanistan and Pakistan. The northern tier's Caucasians are facially and structurally similar to Europeans from Greece to France. And their light-brown skin tones and dark hair are similar to those of the highlanders of Western Asia. The lightest-skinned people are found along the Aegean coast of Turkey and the darkest near the Persian Gulf coast and in Baluchistan in Pakistan.

Whatever their differences, the citizens of the northern tier share a warm-hearted generosity and openness. I found the mountain tribes of Afghanistan and Pakistan, for example, to be as sturdy as the landscape they inhabit. Enduring, fiercely independent, they extended a lusty, warm hospitality. Often characterized as a hard people, the Turks possess a sense of humor and offer a degree of hospitality scarcely known in the West. Wherever I traveled, I was invited to participate in a meal and in tea, tea and more tea!

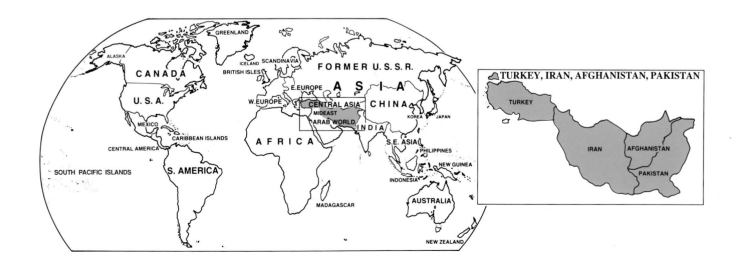

THE BALKANS OF EASTERN EUROPE
The former Yugoslavia, Albania, Bulgaria, Romania

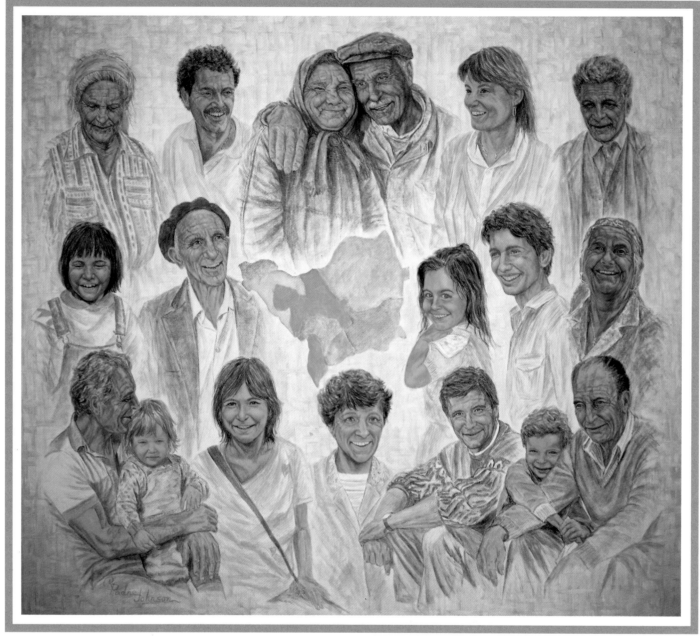

Portrait of The Balkans - East Europe

30" x 34" oil

"I often think, if more people could only take a few more minutes a day to appreciate the similarities and important differences in our humanity, perhaps a new seed of understanding would begin to germinate. This would have the potential of shaping a whole new process of evaluating and understanding the personhood of all members of our global family, including our nearest neighbor of the same color and cultural heritage. Where there is an openness to listen and learn, there is no need to enforce one's views or control the response of another person."

As of this writing, the land of the South Slavs (the literal translation of the word *Yugoslavia*) is experiencing an intense period of transition. What became a Pan Slavic nation in 1918, after centuries of foreign domination and bloodshed, no longer displays the unified colors of a common flag. The Yugoslav federation of historically diverse peoples, representing five nationalities, seventeen minorities, four major languages, three religions, two alphabets and six republics, is now threatened by a mudstorm of independent nationalism.

Perhaps this young Yugoslav nation was never constructed to outlast its major architect, Marshall Tito, a World War II hero, who witnessed the loss of nearly two million Yugoslav lives, about half at the hands of fellow countrymen. Always an unstable federation as volatile as the political past of the Balkan region it occupies, the country faced added pressures when Tito died in 1980 and old resentments began to emerge, fanning the flames of ethnic rivalries and reviving tragic memories of the war.

This land of more than twenty-four million people, with its unsurpassed mountain scenery has the most extensive ethnic and religious diversity in Eastern Europe. The population comprises Serbs (37 percent), Croats (20 percent), Bosnian Muslims (9 percent), Slovenes (8 percent), Albanians (7.8 percent), Macedonians (6 percent) and Montenegrins (2.5 percent).

Throughout the country, cathedral domes stand beside minarets, evidence of the historic influence of Greeks, Romans, Turks and Celts. Yet each of Yugoslavia's nationalities has retained a sense of its own cultural identity. Croatia and Slovenia, ruled by the Habsburg monarchy as Austria-Hungary until 1918, are more western than the republics to the east and south, regions formerly under Turkish rule until the defeat of the Ottoman Empire at the end of World War I. Croats and Slovenes are therefore primarily Roman Catholic, while many Bosnians are Muslim and most Serbs, Montenegrins and Macedonians are Eastern Orthodox.

These east-west cultural differences are also reflected in the dominant language, Serbo-Croatian. It has two written forms, the Cyrillic alphabet of the east and the Latin (Roman) alphabet of the west.

During my last visit to Yugoslavia, I witnessed growing ethnic tensions. Yet in private, Yugoslavs were so similar in laughter and pain, humor and discouragement, their love of freedom and pride in ethnic identity. Perhaps the best hope for the future is that the spirit of good will I shared with each person will promote positive interrepublic communications and a new spirit of respect for differences in this land of so many loyalties.

Like Yugoslavia, its neighbor to the north, Albania also lays claim to a rugged, beautiful landscape, and its culture exhibits a similar fascinating blend of eastern and western influences. This tiny nation, only slightly larger than the state of Maryland, is one of the smallest countries in Europe. Albanians refer to their mountainous homeland as "the country of the eagles," since only about 20 percent of the country is flat to rolling coastal plain. Most of the population live in the scrub-forested hills and mountains.

Albanian ancestry dates to the Illyrain people who inhabited the Balkans long before the Slav invasions of the fifth and sixth centuries A.D. Before the communist takeover in 1944, about 70 percent of the people were Muslim, a legacy inherited from five hundred years of Turkish rule. The Eastern Orthodox (20 percent) and Roman Catholic (10 percent) trace their origins to the missionary activity of the apostles in the first century A.D. Though religious institutions were prohibited by a constitutional decree under a strict communist government in 1967, Albanians continued to practice their religions privately. Today, a new religious freedom permeates the Albanian landscape.

This new spirit of tolerance is especially exciting to witness in Bulgaria, the oldest police state in the region. The principal religion is the Bulgarian Orthodox Church, into which most Bulgarians are baptized. Before 1989, the government discouraged religious activity. A powerful force even during periods of communist supression, the church continues to attract the vast majority of Bulgarians to its services. Today, its new leadership has pledged to support the rights of all citizens to worship freely.

And the government has made other concessions as well. The Bulgarian language is the country's primary tongue, although some secondary languages reflecting its ethnic diversity are also spoken. The most common is Turkish. From 1984 to 1989, the government tried to ban the use of the Turkish language in public because of its anger over years of Turkish occupation. The new leadership has since repudiated that policy.

Sharing the Balkan Peninsula with Bulgaria is Romania, a land of varied terrain that extends inland halfway across the peninsula, occupying the greater part of the lower basin of the Danube River and the hilly eastern region. It also lies on either side of the Carpathian and Transylvanian Alps, which form the Balkan Mountain range.

For the past two centuries, Romania has served as the gateway for Russian expansion in the Balkans. But this was only the latest in a long series of historic invasions. Because of the influences of the Roman occupation in the second and third centuries A.D., most Romanians consider themselves and their language descendants of that civilization.

Almost 90 percent of the people are ethnically Romanians, a group that in contrast to the Slavs is traced to Latin-speaking Roman, Tracian, Slavonic and Celtic ancestors. As a result, the Romanian language, although containing many elements of Slavic and Turkish influences, among others, is more closely related to French, Italian, Portuguese and Spanish. Hungarian and German are also spoken in parts of the country.

For centuries Romanian history has been violent and dramatic. Its territory has seen many invasions from Huns, Goths, Mongols and Turks. Today some suppression still survives after Ceausescu. Yet the people do breathe a new soul of freedom. They are an earthy blend of many ethnic reflections, all desiring to live in peace and freedom. Their inner spirit is warm and inviting. They love to sing, dance, play and make merry at such festive occasions as weddings. Though they still have limited rights, yet they smile and laugh when they meet a friend, and they shared good will with this artist stranger who became a friend.

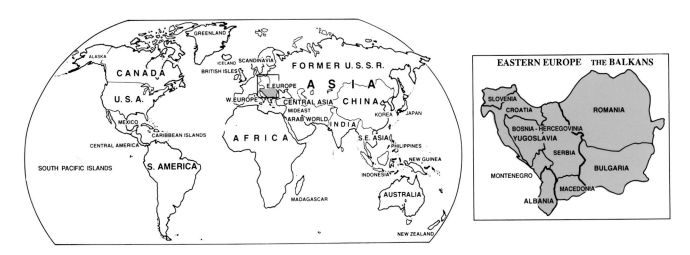

Europe – North Mediterranean
Portugal, Spain, France, Italy, Greece

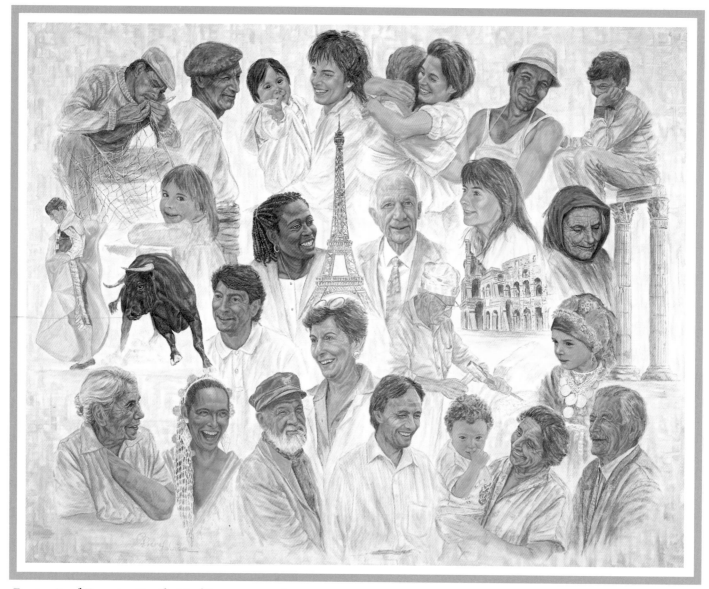

Portrait of Europe North Mediterranean Area

32" x 40" oil

"*Human beings everywhere possess the same biological needs and vulnerabilities. Therefore, it is not surprising that there are many common themes between societies. All across this planet I've appreciated a common human situation humor and enjoyment of family and the family meal. I've also been a participant in their play, spats, risk, pain, dignity, the offering of respect, affection, joy of sharing a gift, anger, pleasure, look of love for one's child, parent and grandparent, look of being in love, or seeing and welcoming a friend. These and many more human expressions are threaded into that eternal tapestry of the global human family, as natural expressions common to all citizens of our earth.*"

A hospitable climate, intriguing ethnic diversity, scenic beauty and legendary culinary delights make the northern Mediterranean countries of Europe a vacation lover's Eden.

Yet these lands of good food, fine wines and sun have histories as volatile as any of their northern neighbors. The populations of the Iberian Peninsula, for example, represent conquering peoples from all parts of Europe—Celts, Scandinavians, Greeks, Romans, Arabs, Berbers and Jews. The Romans described the original people of Spain and Portugal as wiry people with dark skins and small faces. Forcing the Romans out were Celtic tribes which breached the mountain passes of the French Pyrenees into Spain. Later the Vandals of Scandinavia invaded, lending their name to the regions Vandalusia and Andalusia. However, the arrival of the Arab Moors in the eighth century and their five-hundred-year occupation left the most indelible mark on the people. Following a series of successful Crusades, the Christians expelled both Arabs and Jews from Iberian soil. This history is evident in the faces of Spain today.

Among these country people are the Basques, who live on the coast and in the Pyrenees Mountains of both France and Spain, and the Catalans, who live in northeast Spain. Because of the relative isolation of their cultures, both the Basque and the Catalans speak languages distinct from any other in Europe. Incorporating both Spanish and French, the Basque tongue still mystifies philologists, while the Catalan language stems from Latin. The Catalans were the first to be overrun by the Romans, thus the strong Latin origin of their language.

Occupying the north-central regions of Spain are the Castillians, historically Spain's cultural aristocracy. The Castillians, for example, ruled Spain in its zenith as a European power in the sixteenth century. They possess a great flair for festive celebration, from the bull runs at Pamplona to their passionate performances of flamenco song and dance.

Like its neighbor Spain, Portugal is home to a peoples of mixed descent. The Portuguese language traces its roots primarily to Latin, the result of Roman conquest nearly two thousand years ago.

The westernmost nation of continental Europe, Portugal historically found its destiny at sea. Five centuries ago, ships bearing the country's scarlet cross coursed the oceans, exploring two-thirds of the known world at the helms of such explorers as Magellan and da Gama. As a result, more than one hundred million people throughout the world use Portuguese as their official language. Today one of every fifty men makes his living as a fisherman, battling the unpredictable moods of the Atlantic on annual cod-fishing expeditions to Newfoundland's Grand Banks.

Bordering the Iberian Peninsula to the west is France, the land of Napoleon, Pasteur and Dior, whose population is just as ethnically mixed. Along the northwest coast of France in Normandy live the Normans. Descendants of Danes who colonized the soil in the tenth century during the Viking period. Tall and blond, many of today's Normans exhibit characteristics of their Scandinavian heritage.

East of Normandy in northern France live the Picards. Their Latin and Gallo language was influenced by the Romans and Celts, as well as the Flemish-speaking Dutch.

Their neighbors in southern France are known as the Provencals, whose region was first colonized by the Greeks in 600 B.C. Roman legions followed, bringing their Latin culture and language. Today, the features of the Provencals seem closer to the Italians than more northernly Europeans.

Together these regions cover an area as large as Britain and Germany combined. And because France bridges the northern temperate zone between the Atlantic and the Mediterranean, the country is like a continent in miniature, containing nearly every type of climate and agriculture in Europe, as well as scenic beauty, with great rivers, a picturesque Mediterranean south and landscapes ranging from Alpine highlands to plains.

Yet despite their differences in appearance, customs and temperament, the French maintain a sense of nationhood and cultural identity that has fascinated the world since the Middle Ages.

Unlike France, whose population density is less than any other European nation except Greece, Italy, France's neighbor to the south, has the fifth highest population density in all of Europe. This boot-shaped peninsula and its two major islands possess much of the western world's great art and architecture, as well as some of the world's finest cuisines, mountain ranges, valleys, beaches and quaint villages, sure to inspire poetry in even the most unromantic of hearts.

The Italian culture has been shaped by a variety of influences. The first trading expeditions to visit Italy were led by the early Greeks in 1500 B.C. In the eighth century B.C. the Etruscans arrived from Asia Minor, followed in the fifth century by the Celts and Phoenicians. Sicily was first invaded by Greeks, after which the Romans, Arabs and Viking Normans also left their mark. In time, however, the Romans prevailed all across Italy until their empire crumbled in the fifth century A.D., leaving the country open to invasions by Goths, Huns, Moors, Greeks and Asiatic peoples. Among today's Italians, long united in language, this great ancestral diversity is still evident in their physical and facial types.

Unlike its European neighbors, Greece has maintained a more homogeneous ethnicity, even though the Romans, Celts, Goths, Slavs and Turks all have left their mark. Except for such islands as Crete, where Minoan civilization existed as early as 3,000 B.C., the language and physical traits of the Greeks have remained relatively unchanged for the past two thousand years.

Remnants of history grace the landscape just about everywhere you look. Below this fountainhead of western culture and democracy lies the new Athens, a bustling city of broad avenues and glass-sheathed office buildings which serve one of the largest merchant fleets in the world.

But most memorable to me are the Greek islands, which I sailed as a deck hand on board a sixty-foot schooner. I captured the excitement of the island peoples, their food, dance, stories and lusty songs. The images of white buildings clustered against the blue, blue Aegean waters, the donkeys, olive groves, weather-beaten fisherman repairing their nets and the taverns flowing with Retsina are stored in my memory and on film. Lucky me!

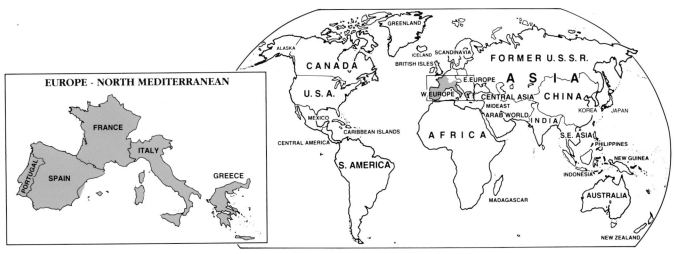

EUROPE - NORTH MEDITERRANEAN

WEST – CENTRAL EUROPE
Netherlands, Belgium, Luxembourg, Germany
Poland, Czechoslovakia, Hungary, Austria Switzerland

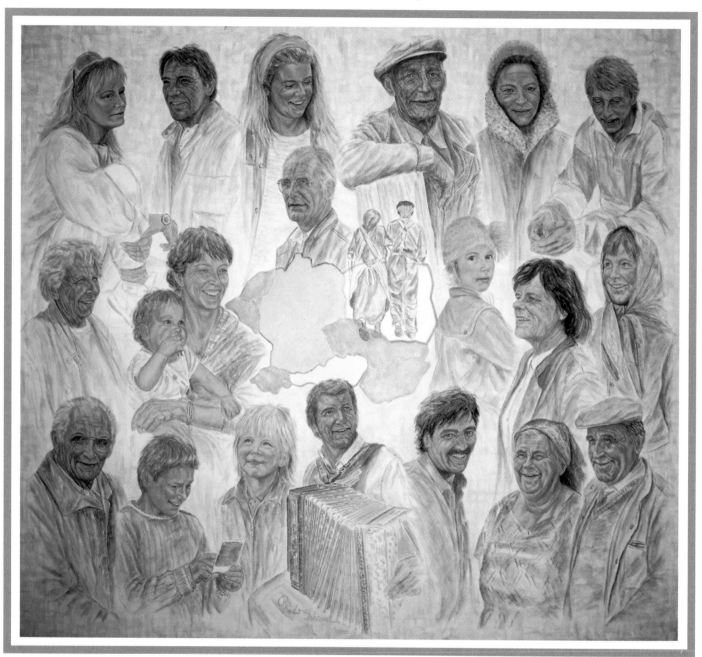

Portrait of West - Central Europe

34" x 38" oil

"*Cultivating a historical perspective serves as a very important ingredient in perceiving how people and cultures resemble and differ from each other. It provides a strategic aid in my need to grasp the complexity and cause of historical events, thus making it less likely that I will always search for simple answers and dismissive explanations. A sense of history has also assisted me to more clearly recognize the impact of political abuses on religion, culture and the role of good government throughout our world.*"

When you travel the continent of Europe, you nearly always tread on ground made fertile by the ashes of history. West Central Europe has been one of the most restless regions on earth. Most of the people are descendants of Celtic, Scandinavian, Germanic and Slavic invaders. Beginning with 500 B.C., the Celts spread out from their homeland in southwestern Germany to all parts of Europe. From the north came the Scandinavians. Some of the Anglos and Saxons moved west as far as England. Other Germanic people pushed to the eastern borders of present-day Poland, Czechoslovakia and Hungary. Their influence was so pervasive that by the ninth century A.D., Germanic tongues were spoken in all but the southern and eastern reaches of the continent, where the French and Italian languages had taken root. Centuries of these invading armies, including the Romans, have resulted in a rich array of ethnic groups and linguistic dialects.

Primarily of Germanic stock, the Dutch population, for example, also exhibits a Gaul and Celtic mixture, which explains their blond, blue-eyed features. Tested by recurring invasions of a variety of European empires, the Dutch have also had to overcome a great geographical obstacle—the North Sea. To keep the destructive power of the sea at bay, the Dutch have devised an ingenious system of dikes, pumps, canals and ditches.

Despite its size (the country is one of the smallest and most crowded nations in the world), the Netherlands was a great colonial power in the seventeenth century. After wars with Spain, England and France in the eighteenth century, its military and political importance declined.

Since then the Dutch have become extremely proud of the accomplishments within their own small borders, pointing to the artistic contributions of Rembrandt and van Gogh, the cultural treasures of their picturesque towns and villages, their high standard of living and their tolerant, open-minded society.

As the crossroads of Europe, Belgium also has witnessed the ebb and flow of many different peoples. Throughout its long history, Belgium was invaded by Celts, Romans, Scandinavians, Germans and Spaniards, producing a unique cultural, facial and linguistic mixture. Today Belgians are divided into the Dutch-speaking north, called Flemings, the French-speaking Walloons in the south and a small German group in the east.

This cultural diversity renders Belgium a United Nations in miniature. And the use of its principal city, Brussels, as the headquarters for NATO makes this tiny nation a continuing crossroads for European culture.

Like its neighbor, Luxembourg's compact size doesn't preclude great cultural richness. German is the primary language, though secondary students learn French in school. Also spoken is Letzebursch, a language similar to Dutch.

Though, unlike Belgium, Luxembourg cannot boast of artists with the stature of Rubens or van Dyck, the country nonetheless is known for its fairy-tale castles that overlook forested valleys and quaint miniature towns.

Germany, the land that has given the world Grimm's fairy tales, Beethoven, Bach, Luther, Einstein, as well as Hitler, is a country as ethnically complex as its contributions to culture and history. Comprising the country's diversity are the Westphalians, Lower Saxons, Holsteiners, Hessians, Bavarians, Swabians and Franconians, each maintaining its own cultural characteristics.

Until its recent reunification, Germany has always been a fragmented society, enjoying nationhood for only the last seventy-five years. Until 1871, Germany had been a patchwork of more than 1,500 political units. That year they consolidated as a single state under the leadership of Chancellor Otto von Bismarck, whose pre-eminence was broken by World War I. Germany once again rose to power under Adolf Hitler in the 1930s, engaging the western world in a bloody conflict which left the country defeated and divided—literally, by the Berlin Wall—into the democratic Federal Republic of Germany in the west and the communist German Democratic Republic in the east. On Oct. 3, 1990, the wall collapsed and Germany was reunified under one flag. Today, this country of eighty million people is the second most powerful industrial country in the world.

As in Germany, the fall of communism has meant new political and cultural beginnings for Poland, Czechoslovakia and Hungary. Here, as in all of Central Europe, invading armies have laid siege to land from the Danube River in Hungary to the cold waters of the Baltic Sea in northern Poland. Among the most recent has been the Soviet Union, who with its military force quelled uprisings in Hungary in 1956 and Czechoslovakia in 1968.

As they struggled to preserve their linguistic autonomy and cultural identity from their powerful occupiers, these countries made great contributions to the arts, especially music. From Poland came Frederic Chopin, from Hungary Franz Liszt and from Czechoslovakia Antonin Dvorak and Leos Janacek.

No less musical is their neighbor Austria, which has produced such classical masters as Hayden, Mozart, Schubert and Strauss. Almost all Austrians are German-speaking, tracing their ethnic, historical and cultural heritage to the Habsburg dynasty and the great Austro-Hungarian Empire. After World War I, the empire was dismantled, leaving many Austrians in present-day Czechoslovakia and Hungary.

Austria's Alpine scenery is nearly as legendary as that of its neighbor Switzerland. This landlocked mountainous citadel with its beautiful hillsides and lakes dates its beginnings to a thirteenth-century pact which consolidated its communities. Today this global banking center, with its strong traditions of democracy and neutrality, recognizes four national languages—German, French, Italian and Romansch (based on Latin).

In my many travels across Central Europe, I noted the diversity and similarities among these members of our global human family. I've watched the open expressions of lovers, the beauty of laughing children, parents and grandparents cuddling their children, elderly people sharing friendly stories and gestures, common expressions of humanity that have long transcended the region's political, cultural, racial and religious differences.

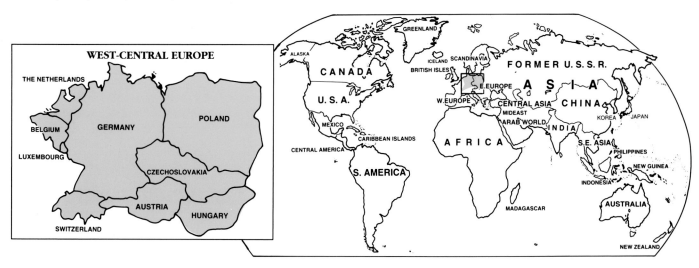

THE BRITISH ISLES
Scotland, England, Wales, Ireland

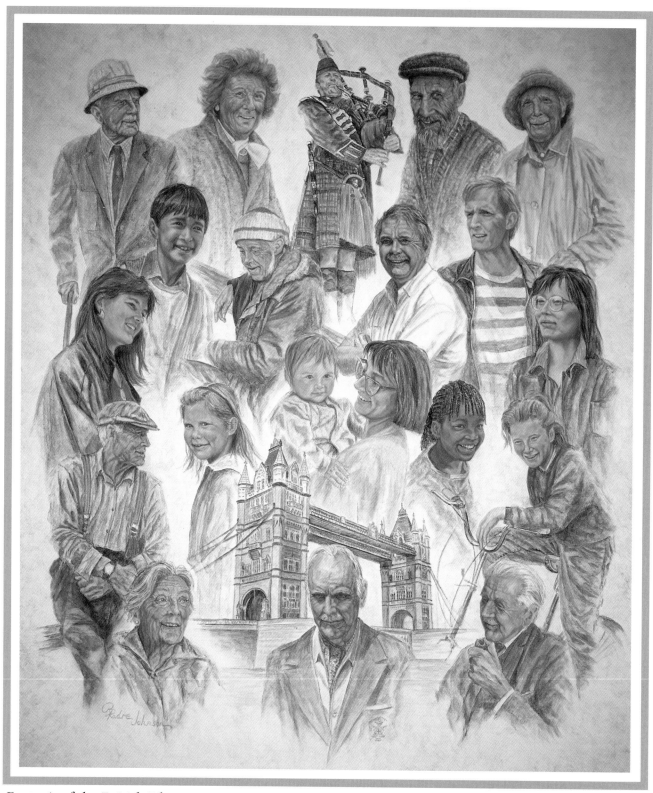

Portrait of the British Isles

38" x 32" oil

"A mature spirit of openness allows us to see, appreciate and respect each person as an individual candle of human worth. A mature spirit also fosters the most inclusive communication between humans of all racial, ethnic, cultural and religious families."

The British Isles, a group of islands close to continual northwestern Europe, encompasses four culturally different countries under one official name, the United Kingdom of Great Britain and Northern Ireland. The countries representing Great Britain are England, Scotland and Wales. Separated by the Irish Sea from Great Britain and occupying five-sixths of the island of Ireland is the country of Ireland. To most visitors, it is known as the most fiercely independent country to occupy the British Isles, having broken away from the United Kingdom in 1921 to form its own independent nation, leaving Northern Ireland a member nation of the United Kingdom.

The present population of the United Kingdom of Great Britain is fifty-nine million, ranking it the fourth largest in Europe after Russia, Germany and Italy. Great Britain, however, is relatively small with few mineral resources. Yet for well over two hundred years until its gradual decline between the world wars, it was one of the most powerful and important countries on earth, its global empire influencing one-quarter of the world's population. So pervasive was its impact that many of the world's legislatures have borrowed features of the British system of government, including Ireland and Britain's former colony, the United States of America.

One of the most urbanized and industrialized nations on our planet, the United Kingdom combines a landscape of exceptional architecture, such as Big Ben and the Tower Bridge in my painting, with a spectacular natural environment of hill, moorland, plain, river, coastline and woodland.

Like the diversity of its landscape, the ethnic background of the people of Great Britain is surprisingly more varied than almost any other nation of similar size on earth. Recorded in its facial diversity is its history of successive invasions by five major peoples–the Romans–the Celts and Saxons from the Alps and mainland Europe–the Vikings–and the Normans from northern France. More recently, this diversity reflects immigration from both inside and outside the boundaries of the former empire.

Though unified, this political state is layered with fascinating cultural differences. For example, among the distant descendants of the Celts, particularly among the Gaelic-speaking Irish, Scotch and Cymric-speaking Welsh, the legacy of poetry and song, storytelling and spiritual devotion is maintained with great pride. However, the most expressive elements of Celtic literature and tradition survives in Ireland. In small country villages and coastal hamlets, ancient Celtic traditions are blended with local customs. The Irish are primarily of Celtic origin, though there are many minority descendants from the Anglo-Normans. English is commonly spoken, though Gaelic is the official language and is taught in the schools. Today the Irish still reflect the energy and lust for life of their tall Celtic and Viking ancestors. Their unquenchable desire for enjoyment spills over in a warm-hearted, friendly cheer that flavors all of Irish society. Their open hospitality and close family ties are constantly reflected in their wonderful facial expressions.

As with the Irish, the Welsh love for music, song, dance, festivals and games is no less passionate. To the traditional Welsh people, Wales is a land of beautiful green valleys and heart-warming songs. Their romantic attachment to their past has allowed the speaking of Cymric, the Welsh Celtic language, to flourish. And in the Scottish highlands and western islands, many farmers maintain the traditional ways of old Scotland. Their ancient, often circular, stone houses demonstrate a link to the past. Here the Celtic custom of holding tribal assemblies at fixed places is recalled by such occasions as the Highland Games. In many areas of Scotland, the Gaelic oral tradition of literature, though originally Irish, also prevails. Though the stories are different, they are remembered and retold in the same broad lusty voices of their romantic Celtic past. Even on my visits in the late 1980s, I found many Scots, Welsh and Irish people in the mountains and valleys little affected by the modern world.

On my seven extended visits to these magnetic islands, I found reflected in the faces of the people of the British Isles a national pride, as well as a pride in the country's strong cultural diversity. But more importantly, each person I selected for my portraits represents for me a very special candle of individual human worth. Each also reflects an interestingly different face and personality, unlike any other in the human family.

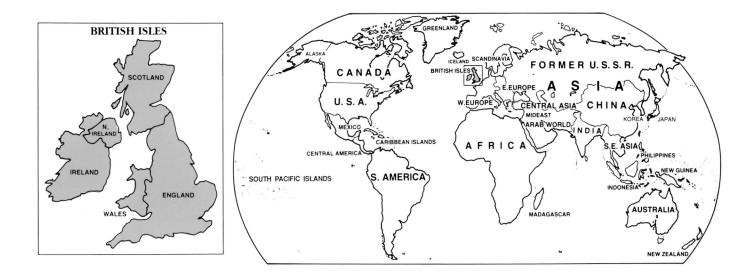

SCANDINAVIA
Norway, Sweden, Finland, Denmark, Iceland

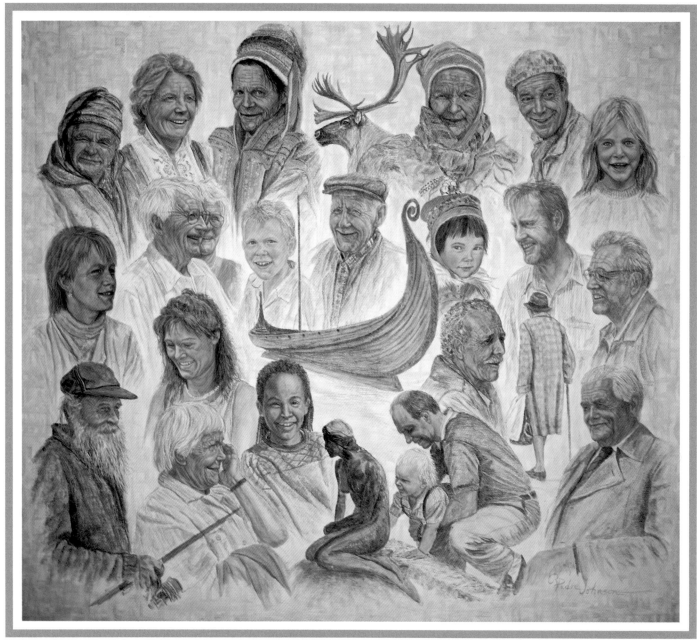

Portrait of Scandinavia

32" x 36" oil

"From my global perspective, no one person or group of people has achieved a pure understanding of the centerpiece of universal truth. Therefore it seems both logical, right and humane to me that no individual or group has the right to impose a religious or cultural way of believing and living on people of differing beliefs."

The Scandinavian countries of Finland, Sweden, Norway, Denmark and Iceland, a union of cooperating states across Northern Europe, may be more appropriately defined as a Nordic family of sibling states, which share a history as well as common values.

Chief among these values is a strong commitment to the welfare of their people, especially their children, disabled and elderly. The Scandinavian social-security system, for instance, is the most extensive in the world. Free health care and education through the university level are available to all citizens. Scandinavia's criminal-justice system is unusually fair, and it also has been in the forefront of pursuing equal rights for women. This has resulted in many women ministers in the states' Lutheran churches and an average of 30 percent representation by women in the various Nordic parliaments.

These public-minded policies reflect Scandinavia's affluence. With its blend of private enterprise and socialism, Sweden, for example, has become one of the most developed countries in the world, having registered more patents than any other country except the United States. Like its neighbor, Norway is one of the richest nations in the world. An influential proponent of liberal foreign trade, Norway maintains one of the world's largest and most modern shipping fleets.

The same energy that fuels the countries' work ethic also underlies their efforts to abolish poverty and illiteracy, to reduce tensions between classes and to help dignify the common person with the same respect given to the privileged. And citizens have been willing to assume a heavy tax burden to finance this secure way of life. Yet the people remain very peaceful and friendly. Throughout this century, Scandinavians have been strong promoters of nonviolence and neutrality, often opposing war as a solution to national and international disagreements, although their warm, hospitable faces clearly exhibit a reserved strength and Viking willingness to defend their own territories.

In addition to their social mindedness, the Scandinavian countries also share a passion for the arts. Sweden, among others, has excelled in the design of glassware, furniture and fabrics. Finland's somber and heroic literature celebrates humanity's unity with nature and stresses the importance of common people. And visitors to Denmark soon discover the Danes' pride in their wealth of literary, artistic, architectural and scientific achievements, as well as their contributions to international cultural relations. Among the Danes' most beloved literary contributions are the fairy tales of Hans Christian Andersen.

But perhaps best of all, Scandinavians are a hardy people with a love for festivity and the natural world. Because of its far northern geographical position, winter has a profound influence on all Scandinavians, shrouding the land in cold and darkness for many months of the year. Subsequently, when winter passes, the people celebrate Midsummer Eve with music, merrymaking and their special passion for sunshine and vacations in the countryside. Yet even in the dead of winter Scandinavians enjoy their winter sports, particularly in northern Scandinavia.

Among those who flourish in the desolate beauty of the north are the Sami, or Laplanders, an indigenous seminomadic people who, when I first visited them in the early 1970s, still made their living herding reindeer, fishing, hunting and trapping all across northern Finland, Sweden and Norway. Today, Sami culture, though rooted in Central Asia, is more closely integrated into Scandinavian society. Yet they remain very assertive about the uniqueness of their culture, language and territorial rights. Even today, about 10 percent of the approximately sixty thousand Sami who live across Scandinavia's northern tier still herd reindeer, while the rest live on small farms. The two Sami faces depicted in the top middle of my painting wear the traditional dress I saw on my first visit twenty years ago. Today this colorful attire is worn only at festival celebrations and by some of the very elderly.

Though the Sami can be found throughout most northern parts of Scandinavia, each country maintains varying levels of ethnic diversity. Today numbering about five million, Finns migrated to their present location thousands of years ago, most likely from west-central Siberia, and soon thereafter began pushing the indigenous Laplanders into the more remote northern regions of Finland, where they remain to this day. The language of Finns and Laplanders share the same origin—the Fino Ugric of the Urals, from which the Hungarian and Estonian languages are also derived. Although 95 percent of the people speak Finnish as a first language, Swedish is also an official language, with English the second language for most Finns. For the most part, the population is ethnically homogeneous.

With the exception of the ten thousand Sami in the far north, Norwegians come predominantly from a Germanic root. In recent years, Norway has become home to increasing numbers of immigrants and refugees from all over the world. More than two thousand of them obtain citizenship each year.

In Denmark, aside from a small German-speaking minority, a mixed Innuit-Danish population in Greenland and the Faroe Islands and the influx of recent immigrants, the Danes are a homogeneous Gothic-Germanic people who have inhabited Denmark since prehistoric times. During the Viking period, from the ninth through the eleventh centuries, Denmark, along with Norway, was one of the world's great powers.

Like Denmark, Iceland is remarkably homogeneous in race, creed and tongue. Most Icelanders are descendants of Norwegian Viking settlers in the ninth and tenth centuries and Celts from the British Isles. Its language is closest to old Norwegian (old Norse) and has remained relatively unchanged since the twelfth century. Following a plebiscite, the country was formally established as an independent republic in 1944.

Unlike its neighbors, Sweden has a more diverse population, with seventeen thousand Sami in the north and more than four hundred thousand immigrants from Yugoslavia, Greece, Turkey, Iran, Africa and East and Southeast Asia. More than one million people are either foreign born or children of foreign-born citizens, and many new immigrants continue to cross Sweden's borders each year. Thus, the face of Sweden is changing, but without losing its friendliness, hospitality—and humor.

Most Scandinavians have a dry sense of humor about themselves, which gives them a healthy balance between the material goods they enjoy and their maintenance of strong human values. Their faces reflect this inner strength.

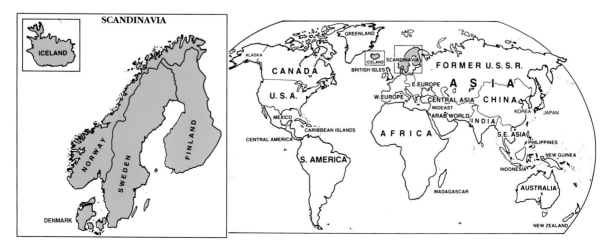

FIFTEEN REPUBLICS OF FORMER USSR

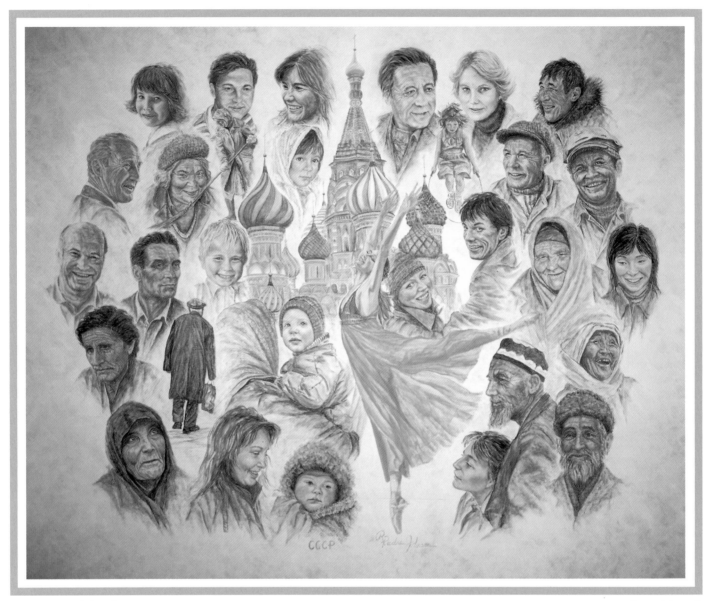

Portrait of the former USSR 36" x 44" oil

"In this approaching new century, change is inevitable. Once-opposing nations will sign alliances of friendship, and those that were once territorial and global allies will find new uncomfortable differences fracturing their previous union. But in time, the unpredictable, but inevitable, slow-moving process of historical change will bring those opposing forces back together in a new spirit of sharing their newly acquired cultural values, instincts and customs (habits) on the newly reshaped cultural-exchange landscape of the twenty-first century."

On December 25, 1991, Soviet President Mikhail Gorbachev stepped down after six years as head of state. With his resignation, the Union of the Soviet Socialist Republics (USSR) officially disbanded as a political entity. Lowered for the last time from the Kremlin in Moscow was the Soviet red flag, with its hammer symbolizing the country's workers and its sickle the farmers. Taking the Soviet Union's place has been a very fragile commonwealth of independent states comprising eleven of the former Soviet republics, including Armenia, Azerbaijan, Byelarus, Kazakhstan, Moldova, Russia, Tadzhikistan, Turkmenistan, Ukraine, Uzbekistan and Kyrgyzstan. Georgia and the three Baltic republics of Lithuania, Latvia and Estonia, which had become independent states earlier that year, declined to join the commonwealth.

Before its dissolution, the USSR ranked third in the world in population. Today its largest republic, Russia, home to 150 million people, contains nearly one-sixth of the earth's land mass. Its great sweep of tundra, forest and steppe is so large that it spans eleven time zones.

The Russian language continues to be widely used and is still promoted as a second language for all non-Russians. It is one of the common denominators held over from a former union that comprised more than one hundred nationalities. Out of this spectacular complexity, the Slavs made up the largest ethnic group and included the Russians, Ukrainians and Byelorussians, all of whose religious heritage is almost predominantly Orthodox Christian.

The Slavs speak Slavonic languages closely related to those spoken throughout Eastern Europe, such as Polish, Czech, Serbo-Croatian and Bulgarian. Their Cyrillic alphabet is well adapted to reproducing the sounds of these Slavonic languages.

The Slavs originally inhabited the vast plains north of the Black Sea and west of the Ural Mountains. Today, however, they are found all across the former USSR. For example, northern Kazakhstan, which once was inhabited only by nomadic Kazakh tribespeople, today is home to primarily Russians.

The former union's second largest group is the Muslims. Though the nomadic Kazakh, Kighiz and Turkmen have almost all completed a transition to sedentary life, differences in points of view and lifestyle remain between them and the Uzbeks and Tadzhiks whose agricultural societies are centuries old. (See map for location of these groups.) Converted to Islam in the early Middle Ages, the Central Asians still feel a close link to the empires of Genghis Khan and Tamerlane, whose tomb is located in Samarkand. The Azerbaijanis, or Azeris, whose capital is the oil city of Buku on the Caspian Sea, are fundamentalist Shiite Muslims, unlike the great majority of Sunni Muslims in East Asia. Despite the fact that their language is almost identical with Turkish (the majority of Muslims in the former USSR speak the Turkic languages), the Azerbaijanis maintain closer ties with Persian Iran than the Arab world and Turkey.

Even under the unifying yoke of the former USSR, most citizens identified with their religious or ethnic backgrounds before their Soviet citizenship. If you had asked a Central Asian how he had regarded himself under the old regime, he would have privately confessed, "I am a Muslim first, an Uzbeck, Kazakh, Turkman, etc., second and a Soviet citizen last."

Among the Estonians, Latvians and Lithuanians, a self-assertive attachment to their national language, traditions and achievements has always been a source of immense pride. These Baltic people stress that they have always had closer ties to Europe, particularly to Sweden and Germany who ruled the region for centuries. Enjoying a new-found independence since 1991, the Baltic States had heretofore only tasted brief independence between 1918-1939, when a pact between Hitler and Stalin ceded these republics to the Soviet Union.

The Scandinavian heritage among the Estonians and Latvians is readily recognizable. Their taste for clean, simple, light and airy design is similar to their northern Scandinavian cousins. And the Estonian language is close to Finnish. Unlike the Estonians and Latvians, who are primarily Lutheran, the Lithuanians are devout Catholics like their Polish ancestors.

If the Baltic states served as a transition between Europe and Russia, Transcancausia, which includes Georgians, Armenians and Azerbaijanis, was an intermediary between Europe, the Middle East and Western Asia. In its territory East met West. The Azeri Muslims, for example, have been influenced by the Shia Muslims in Iran. By contrast, the two Christian peoples of the region, the Armenians and Georgians, have traditionally looked to Russia as a source of protection. This intercession was especially critical for the Armenians, a homogenous ethnic group that has endured a long history of persecution by Turks. On the other hand, Georgians comprise nearly seventy distinct groups and dialects, which are neither Indo-European, Turkic nor Semitic. Defying neat distinctions, the present Georgian nation is a fusion of aboriginal inhabitants with immigrants from many surrounding regions.

Perhaps no region of the former USSR stirs the imagination as Siberia, a place synonymous with arctic bleakness and exile. In reality, Siberia is a land rich in human culture, home, by some estimates, to more than sixty-five native peoples, not including the Russians, Ukrainians, Germans and others who have settled the area since the 1950s as voluntary workers, after Premier Khruschev released millions of slave laborers following the death of Stalin. Tribal Siberians are descendants of the great Asian empires of the Mongols, Turks and Tartars. Among them are the Chukchi and Koryak, two Innuit groups I met on my Siberian visits.

Among my many travels with the people throughout this vast region, I shall never forget the unbelievably friendly hospitality granted to me by the people of Droozhboo and Prepete. Although they had suffered the disaster of Chernobyl and a subsequent relocation, they nonetheless managed to be open and gracious to a stranger in their midst.

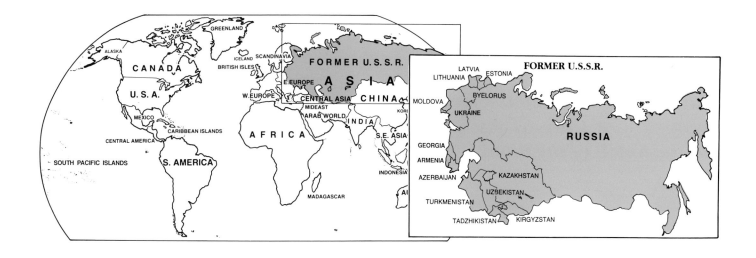

CHINA, TIBET, MONGOLIA, KOREA

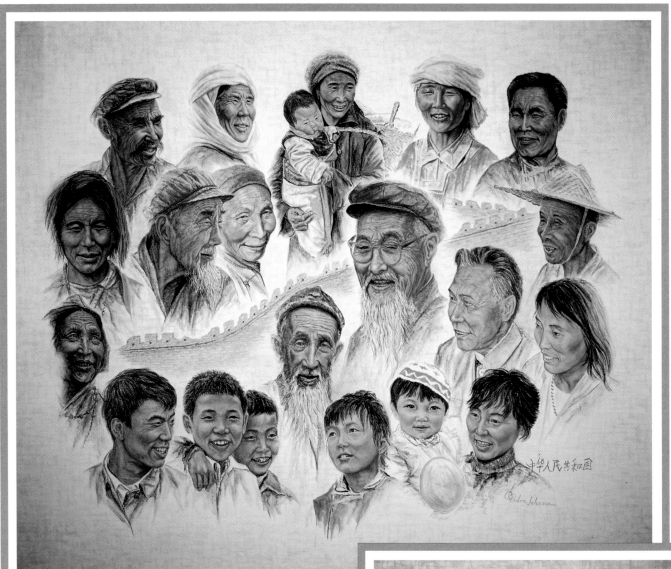

Portrait of China, Tibet, Mongolia 36" x 44" oil

"The value of each unique individual human being deserves my clear respect through the look in my eyes, the tone of my voice and the touch of my hand."

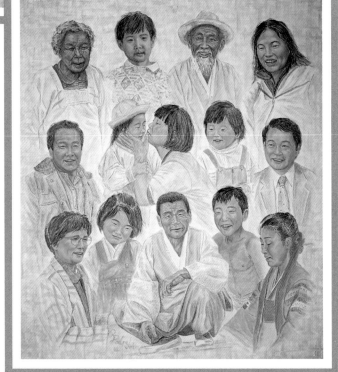

Portrait of Korea 24" x 28" oil

In terms of its size, climate, population, industrial development and history, China is a land of extremes. Often referred to as the People's Republic of China (including occupied Tibet), this East Asian country is the third largest in the world, after Russia and Canada. Its fourteen thousand miles of border are shared with Korea, Russia, Mongolia, Kazakstan, Kygyzstan and Tadzhikistan of the former USSR, Afghanistan, Pakistan, India, Nepal, Bhutan, Burma, Laos, Vietnam, Hong Kong and Macau.

China also is the oldest recorded civilization, its history spanning more than four thousand years. The ancient Chinese built the largest structure ever constructed, the Great Wall. Completed more than two thousand years ago, this incredible monument to human endurance winds its way 3,790 miles through valleys and over mountains, from the coast northeast of Bejing to the deserts of Inner Mongolia. I included the Great Wall as the only symbol representing this unique subcontinent because of its uniqueness—it is the only humanmade structure visible from outer space.

For centuries, China has been the most populous nation on earth, even though two-thirds of its land is semidesert and mountainous. Only about one-tenth of China's land is cultivated. Ninety percent of its people live on one-sixth of the land, primarily in the fertile plains and deltas of the east, where the country's three major rivers flow— the Yellow, Zangtze and West rivers. Today the population has exceeded one billion people. Though the government has vigorously pursued a national family-planning program over the past thirty years, the birth rate continues to climb. Currently, China is home to more than one-fifth of all people on earth.

By far the largest ethnic group is the Han Chinese, comprising about 94 percent of the population. The Han trace their ancestry to the founders of the Han dynasty and see themselves as the true Chinese. Though Mandarin is their written and spoken language, the many Han subgroups speak in hundreds of dialects. The remaining 6 percent includes fifty-five officially designated minorities, all with their own customs and lifestyles.

Each time I traveled in this overwhelming nation, I marveled at the continuity of past and present. Old China still lives on in hundreds of ways. Bureaucracy and family are as dominant in China today as they were in the third century B.C. By some estimates, nearly one out of every eight people are party bureaucrats or members of their families. People rely on patience and persuasion to get things done in the face of this enormous governmental bureaucracy. Family still forms the main structure of Chinese society with children learning to respect authority and the elderly maintaining their customary places of esteem.

By contrast to the numbers of public officials, professionals and industrial workers, peasant farmers still comprise nearly 80 percent of the population. Only 12 percent of the country, however, is good farm land. For the most part, traditional practices prevail, even though farmers are now allowed to earn extra income by producing and selling their own crops. Farming continues to center around old market towns, and the land is worked by hand.

The central government also has made other concessions, granting semiautonomous status to five regions with high minority populations, including Guanqxi, Ningxia, Inner Mongolia, Xinjtang and Tibet. Minorities in these areas are permitted the use of local languages in schools and regional radio broadcasts, as well as exemptions from rigid birth-control regulations. Those minorities with the most distinctive cultures are the Muslim Uygurs, Kirqiz and Kazaks (whose faces are depicted in the top left corner of my painting) in the northwest and the Tibetans, followers of the Dalai Lama, in the southwest (illustrated in the painting's far left).

But environment and lifestyle seem to differentiate these people more so than religion. The Tibetan homeland, for example, occupies the world's highest lands. Even for the seasoned traveler, the first sight of Tibet is overpowering. Its winters are arid and cold and the land sparsely populated, even in the valleys where most the country's two million people live. Farmers and small nomadic bands use the vast stretch of steppe and mountain that lies between the valleys to graze their livestock and the shaggy yak, which, impervious to the bitter cold, supplies not only milk, butter and meat but hair for weaving tents.

The Tibetan way of life is simple, with few daily amusements, among them the wonderfully pungent yak-butter tea I learned to enjoy after being the recipient of so many expressions of Tibetan hospitality. Spontaneous singing and dancing at local festivals and ceremonies enliven their lives, especially around the new year, and the people love to go on picnics. They are a happy people who love to travel, especially on long pilgrimages to holy places.

Just as awe-inspiring is the Mongolian landscape, a sparsely populated land of high plateaus, rugged mountains, huge forests and bleak deserts swept by frigid winds. Though some Mongols are still nomadic, following their herds and living in yurts, more than half the population works on large cooperative government farms and resides in urban or semiurban areas. Yet like their fellow countrymen who roam the plains, these urbanized Mongols still share a passion for horse racing, wrestling and archery.

The influence of these wide-ranging nomads has extended as far away as Korea, where the people, descendants of Mongolian invaders, share many of the same facial and physical characteristics. Like the Mongols, Koreans tend to be taller and more robust than other oriental people, with a Mongol fold of skin over the inner angle of the eye, a ruddier, olive complexion, round faces and hazel eyes.

I believe my paintings of China, Tibet, Mongolia and Korea truly capture my insight into the open faces of the vast area of far East Asia. During my three extended visits to the region, I enjoyed their hospitality and appreciated their unique facial and ethnic diversity, from the remote mountain wilderness of Tibet and the northern frontier, across the grasslands of Inner Mongolia (where I raced a champion horse to a close finish) to the heart of mainland China. In their after-work hours, even the poker-faced Bejing commuters shared private moments of song, jest, play and laughter. Their curious, accepting and joyful faces have left an indelible mark on my memory.

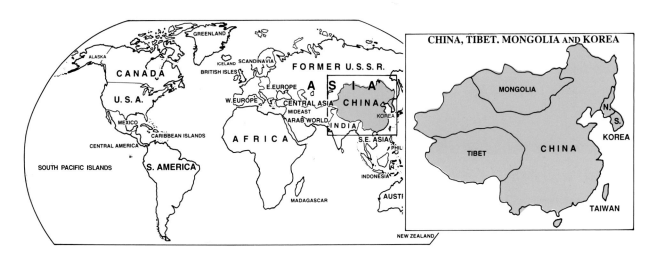

JAPAN

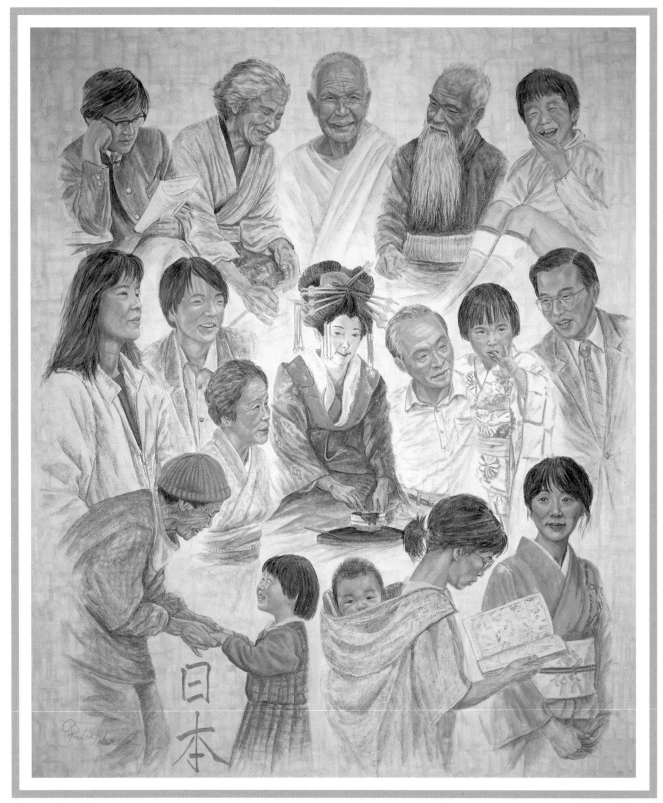

Portrait of Japan 38" x 32" oil

"As the open-minded student of life continues to openly listen, watch and learn from the people and societies he/she is closely observing and enjoying, an appreciation and respect develop for the intrinsic values and differences in all other cultures, as well as a deeper appreciation for his/her own cultural roots."

With a population of 125 million people, Japan is also one of the most densely populated nations in the world—823 persons per square foot. Due to strong government support of family-planning programs, the birth rate of this small nation has stabilized in recent years. This stabilization is particularly important in Japan since mountains and hills cover approximately five-sixths of the land, forcing more than one-half of the population to live along the coasts.

Japan's crowding, as well as its isolation until 1853, when Commodore Perry forcibly opened its doors, have uniquely shaped the Japanese character. In just over one hundred years they have gone from a feudal people closed to the outside world to a nation respected globally in international economic affairs. Part of this economic miracle can be traced to their sense of shared obligation and social duty. For instance, individual Japanese tend to view themselves as members of a team all working together toward the common good and goals of the group. In the Japanese workplace, attention to detail and cooperation are part of every activity—from producing a computer chip to designing a new car. These qualities also make for a very law-abiding society.

Though Japanese are often characterized as workaholics, they are increasingly finding time for leisure activities, such as gardening, reading, meeting friends in Tokyo's more than ten thousand after-work bars, sports, festivals and music, which allow time for joy, laughter and the open child to emerge in their faces.

The small size of the Japanese home serves to tighten family bonds. In most dwellings, infants sleep with their mothers and older children sleep together. Family members study and work in confined common spaces. The Japanese have turned this physical necessity into a way of teaching cultural values, ranging from respect for authority, cooperation and the desire to please to the intricacies of Japanese etiquette.

Yet most visitors strolling through Tokyo's crowded streets might feel that the Japanese are abandoning their traditional ways to embrace a bizarre mix of European and American influences. This outward appearance is rather deceiving. For even though the Japanese seem determined to become the most cosmopolitan people—reshaping their own culture to incorporate the ideas of foreign cultures—they remain a traditional people, which is symbolized by the geisha in the center of my painting. Today the geisha (meaning "cultivated person") is still a symbolic integral part of Japanese society. Before she can become a geisha, she must master the traditional regimen of dance, song, the art of conversation, flower arranging and conducting the tea ceremony. This education takes years to complete.

Though most Japanese have only a nominal connection to their Buddhist religion, Buddhist priests are still called upon to conduct religious ceremonies, including funerals and ritual commemorations of ancestors. Daily offerings are made to household altars which contain tablets inscribed with the names of departed relatives. While most urban dwellers do not formally practice any religion, they are avid celebrants of such occasions as the New Year, holy days and midsummer religious festivals. And their ancient intense love of nature continues to prompt present-day Japanese to organize parties celebrating the full moon or the spring's cherry blossoms.

The Japanese language also has deep roots in Japanese history. In the sixth century A.D., the Chinese written alphabet was introduced by Buddhist priests and scholars. Therefore many Chinese words found their way into the Japanese language. After many unsuccessful attempts to use Chinese characters to express Japanese phonetics, the language was written in the hybrid form which exists today. Although there are many regional dialects, differences in speech are not great enough to seriously hinder communication between regions of the country. In this respect Japan differs markedly from India and China.

Though language may vary, one of the most striking features of rural Japan is the uniformity of its cultural geography. The country hamlet with its tightly clustered group of farm houses and shops is characteristic of most rural settlements throughout Japan. While many traditional aspects of rural life have survived, increasing industrialization has led to radical changes in the countryside, including modern farming methods, as well as migrations from outlying regions to the cities over the past two decades.

One of the more fascinating rural areas is the northernmost of the Japanese islands of Hokkaido, home to its vanishing race of indigenous Ainu people. The pure-blood Ainu look quite different from the Japanese and their other Mongoloid neighbors. Many anthropologists feel that they closely resemble the Maori of New Zealand. Unlike most Japanese, the Ainu have hair all over their bodies, their men sporting full beards and moustaches. Their eyes, often chestnut in color, lack the Mongol fold, and their noses are prominent, as illustrated by the elderly Ainu man in the top row of my painting.

Japan has been described as the first society to combine the sensibility of modern mass culture with the house rules of a smaller tribe. Still somewhat culturally isolated from the rest of the human family, they have made the happy discovery that their house rules suit them ideally to the needs of today's modern world, rules, however, that may have to be revised to meet the future challenges of a changing world.

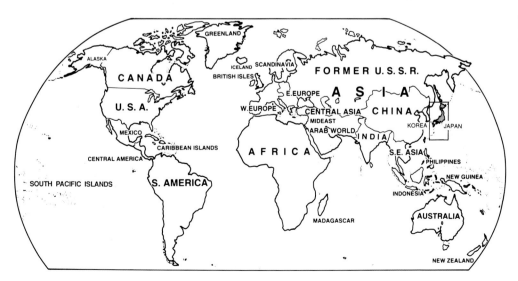

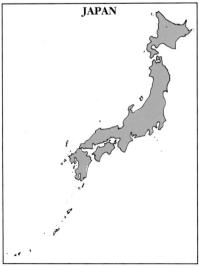

SOUTH ASIA — SUBCONTINENT
India, Nepal, Bangladesh, Sri Lanka

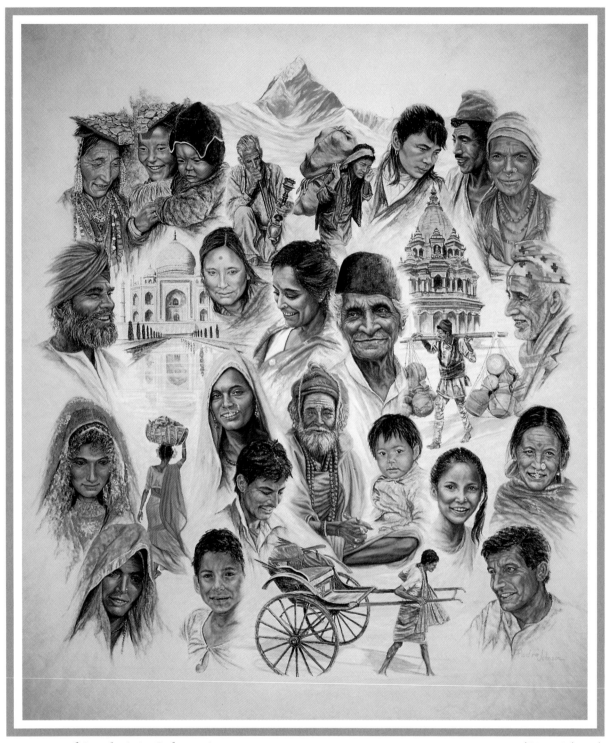

Portrait of South Asia Subcontinent 40" x 34" oil

"When humor, especially the luxury of self humor (laughing at one's self), flavors the human drama, something happens that literally frees one's spirit to discover the goodness in others. It's the oil that also opens the mind to trust certain conditions that may exist beyond one's physical and psychological control."

Nearly 3,500 years ago, Aryan invaders from Central Asia spread over South Asia and founded one of the oldest civilizations on earth—India. Today this seventh largest country with a population of over 750 million (16% of the human family) still nurtures its ancient heritage, one which has been tempered by many hundreds of years of foreign invasions and influence. This is a nation of intriguing paradoxes with a racial, cultural, linguistic, and religious diversity almost unparalleled on earth.

In India, three major races exist. In the north and in large sections of the Indian peninsula, the Aryan, a Caucasoid race, dominates. In the mountainous Himalayan region dwell people of the Mongoloid race, as represented by the three faces from Ladakh in the upper left corner of my work. While in central and southern India, an aboriginal people known as the Vedda, or Dravidian, reside.

Likewise, the languages of these groups form four major linguistic families—Indo-Aryan, Dravidian, Tibeto-Burman and Austra-Asiatic. From these over 15,000 other languages and dialects are recorded in India, with Hindi being the most prevalent. This linguistic diversity continues as one of the greatest impediments to the country's political unity because it fosters regional patriotism. The centuries of British rule lessened this. But ironically, despite its association with colonialism, English survives as the main language of government because it is the tongue all educated Indians know.

The central unifying force which pulls Indian society together is Hinduism. Eighty-three percent of the Indian people are Hindu, and the religion's system of caste has left noticeable marks on the nation's cultural patterns. It still structures most of Indian society to this day, especially in rural areas.

India is also the home of more than eighty million Muslims, giving it the world's largest Islamic population. Christianity, which has been present in southwestern India since the first century A.D., has nineteen million followers. There are also about fifteen million Sikhs (represented by the bearded man on the left side of my painting), whose religion is a mix of Hinduism and Islam that rejects the concept caste. Another ten million Indians are Buddhists and Jains who trace their roots to the late sixth century B.C., while many of India's tribal peoples, upwards of sixty million souls, adhere to a belief in Animism and venerate the mysterious forces embodied in nature and all natural things.

India has three distinct topographical areas, beginning with the sparsely populated Himalayan Mountains along the northern border to the heavily populated and fertile Gangetic Plain to the Deccan plateau in the south and central parts of the country. The climate, too, varies from tropical in the south to temperate in the north.

Since its beginnings in 2500 B.C., India has endured a succession of foreign invaders, absorbing their various cultures and transforming its own. First came Aryan tribes from Central Asia in 1500 B.C., then the warlike Moguls in the seventh and eighth centuries A.D., who remained in power until the late 1400s. Then came the epoch of Western dominance. The Portuguese, led by Vasco da

Gama, reached the peninsula in 1497 and monopolized European trade with India in the 1500s. They were followed by the Dutch in the sixteenth century and the British and French in the early seventeenth century. In the mid-eighteenth century, the British became the rulers of Bengal and steadily expanded their influence until, by the 1850s, they were the masters of all India, controlling the entire area of present-day India, Pakistan and Bangladesh. But beginning in 1920, the Indian leader Mahatma Gandhi with the help of the Indian National Congress and the masses, and using nonviolent resistance and noncooperation, realized their goal of independence from Great Britain on August 15, 1947. Shortly after, however, internal strife and religious differences led the two Islamic provinces to the northwest (West Pakistan) and the northeast (East Pakistan) to secede from India. Then in 1971, East Pakistan gained its independence from West Pakistan to become Bangladesh.

Bangladesh, a low-lying riverine country on India's eastern border, was formed by a confluence of five major rivers, including the Ganges. Modern Bangladesh consists of almost 115 million people, 97% of whom are Indian Bengalis, a very dark-skinned people who speak Bengali and are substance farmers growing rice, jute, wheat and tea. Crowded and poor, Bangladesh has a per capita gross domestic income of only $180 (1989) annually. Yet despite this great poverty, the population, which is 85% Muslim and about 14% Hindu, has a warm and courageous spirit.

Home to the awe-inspiring Himalayan Mountains, with Mount Everest as the highest peak in the world, Nepal was, until recently, known as the "Forbidden Kingdom." The country, about the size of England or the state of Florida, has only been open to tourists for a few decades. But anyone who crosses its borders will be spellbound by its mystical vistas and magical people. The Nepalese, descendants of three major migrations from India, Tibet and Central Asia, include the Sherpas, who are renowned mountain climbers, and the Gurkhas, fierce fighters who were often recruited by the British and have always distinguished themselves in battle. The Nepalese are also largely Hindu, with an influential Buddhist minority.

Lying off India's southern tip is the island nation of Sri Lanka, a republic of over 16 million. With mountains in its central region and miles of magnificent beaches, Sri Lanka, or Ceylon, remains one of the most beautiful countries in the East. Traders seeking spices and jewels have traveled there for centuries. First the Arabs, Chinese and Greeks, then the Spanish, Italians, Portuguese, Dutch and British. Often, those who went there to trade settled with the original inhabitants, the Veddas and Sinhalese, to create a racial diversity that still exists in Sri Lanka today.

During my three visits to these fascinating and beautiful parts of South Asia, I was moved by the openness and happiness of its many relaxed, yet hardworking people, whose moods easily change from fun-loving expressions to salty good humor and open amusement with one another. This unforgettable part of the world, which continually seems ablaze with color and joyful sounds, provided the subject matter and inspiration for this painting.

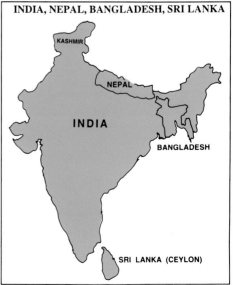

59

SOUTHEAST ASIA
Burma, Laos, Vietnam, Cambodia, Thailand, Malaysia, Singapore

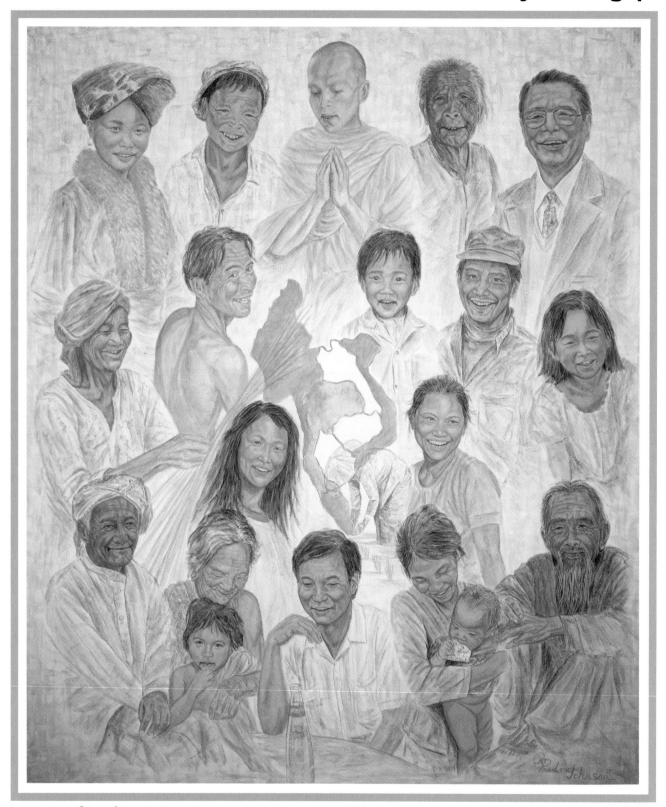

Portrait of Southeast Asia

30" x 36" oil

"The risk of openness provides the key for dismantling the restrictions and prejudices that so often prevent the people and nations of our miniature life-breathing planet from realizing effective and workable solutions to our common problems."

East of India and south of China lies the exotic peninsula of Southeast Asia, the "rice basket" of the world. Since World War II, Southeast Asia has had increased global attention, starting with the prolonged struggle against the French occupation of the region in the 1940s and 1950s and culminating in the war between North and South Vietnam. Ethnically and culturally, however, Southeast Asia has been most influenced by the migrations of the Chinese and Indians.

Approximately the size of Texas, Burma is the largest country in Southeast Asia. Facing the Bay of Bengal and the Andaman Sea, it shares borders with Thailand, Laos, China, India and Bangladesh and is rimmed with rugged mountains and dominated by mighty rivers, dense tropical forests and fierce monsoons. There, nature and the seasons rule, and much frivolity and laughter occurs, especially during the monthly festivals celebrating the full moon. Over 80 percent of the Burmese also practice Theravada Buddhism, dotting the landscape with a seemingly limitless number of Buddhist monasteries, temples and shrines.

At the heart of mainland Southeast Asia sits Thailand. Its population numbers fifty-seven million and is ranked as one of the fastest growing in the world. Bangkok, its capital and industrial and cultural center, is a burgeoning modern city with ornate gilded architecture and impossible traffic jams. Over 80 percent of the Thai people, however, live in rural villages, and three out of every four grow or sell rice. The other essential feature of Thai life is Theravada Buddhism. Every Thai male is expected to spend at least a brief period before marriage as a monk. In fact, Theravada Buddhism has shaped the Thai into a people who basically avoid extremism or fundamentalism or violence of any kind. Wherever I traveled, I benefited from their innate grace and concern for others and was always shown the respect and generosity of a people known for their light-hearted, pleasure-loving ways.

The rain forests of southern Thailand give way to Malaysia, which occupies the lower half of the Malay Peninsula and the northern quarter of the neighboring island of Borneo. A fascinating land of many races and cultures, Malaysia has seventeen million citizens and many ethnic groups. The rural Malays, the largest segment of the population dominate the country politically and by constitutional definition are all Muslim. In contrast, most city dwellers are Chinese, Buddhist or Christian, and wield considerable economic power by controlling the nation's trade and businesses. Malaysia's other minorities include Indians from India, Pakistan and Sri Lanka, and Dyaks and Kadayans from the islands, who all practice their own native religions and ethnic customs.

At the tip of the Malay Peninsula is Singapore, one of the most densely populated nations in the world. Most of its people live in the city of Singapore, with its thriving banks and businesses. A glittering place of flashing neon, tall skyscrapers, high fashion and fast foods, Singapore has a varied linguistic, cultural and religious heritage. Malay is the national language, but Chinese and Tamil also are official languages as well as English, which is used in government and in the schools. A festive, enjoyable and hardworking peo-

ple, they believe in religious freedom for all and possess all of the modern conveniences of the Western world.

To the north of Singapore strategically located within the peninsula is Laos, a country almost exactly the size of Great Britain. A buffer zone between China, Thailand and Vietnam, Laos has a population of about four million, which is concentrated in the valleys of the Mekong River and its tributaries. It also provides the Lao with much of their culture, for it is said that the rising and falling waters bring fertility and carry away evil, guilt and trouble. Religion, too, is central to the daily lives of the people with Buddhist festivals, celebrations and rituals punctuating the Laotian yearly calendar. Among the mountain tribes, however, like the Hmong (represented by the young woman in my painting with the shaved forehead and elaborate turban), Animism, or a belief in spirits, is also common as is the worship of numerous household deities.

South of Laos and Thailand lies Cambodia, whose seven million inhabitants are direct descendants of the Khmer. They ruled from their capital at Angkor, as one of the most powerful empires in the history of Southeast Asia until their defeat by the Thai in 1431. Most Cambodians are rice farmers, and all have known glory, war, defeat and domination by both foreign powers and internal factions. The purges of the Khmer Rouge during the 1970s, left hundreds of thousands of Cambodians dead and many others as refugees. Yet in times of peace the Cambodian people are a festive easy-going group with a wonderful sense of humor. They love to laugh and sing and tell stories. They are also very tolerant of other religions, though they themselves practice Buddhism, and are known for their great affection for and indulgence of their children.

Like Cambodia, much of Vietnam is flat and marshy with many jungles and mangrove swamps. A country over 3,000 years old, Vietnam has always felt its strong connection to the growing and harvesting of rice and the annual rhythms of the monsoon. South Vietnam is dominated by the Mekong River and its tributaries, while North Vietnam is more mountainous and hilly. But both have been influenced by the Chinese, who controlled the region for many centuries. Nearly one hundred years of French rule (1858-1954) also left its mark on Vietnamese culture. Various ethnic groups make up Vietnam's current population, with nearly 1.3 million Chinese in the south, the Southern Montagnards and the Thai in the north, and the Khmer Krom near the Cambodian border at the mouth of the Mekong being the three largest minorities. Among the many hill tribes, skin color ranges from the lightest brown to the darkest black, with many bearing a resemblance to the Indonesians and Filipinos, whereas the Vietnamese who farm the delta are paler and look more like the Chinese.

It was in the Vietnamese delta as a Navy Medical Chaplain during the Vietnam war that I came to know and admire the Vietnamese and their culture. Today, the peoples of this war-weary land are experiencing a new sense of tranquility, freedom and openness, and it remains my sincere hope that peace will prevail in the region.

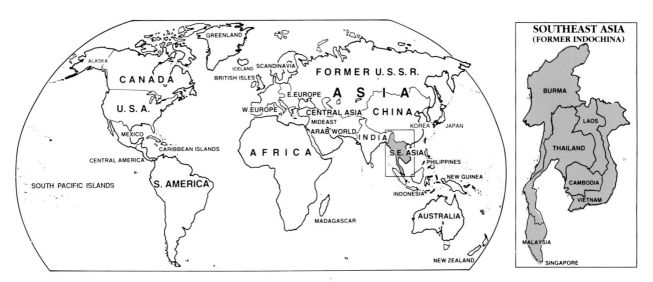

INDONESIAN ARCHIPELAGO & THE PHILLIPINES

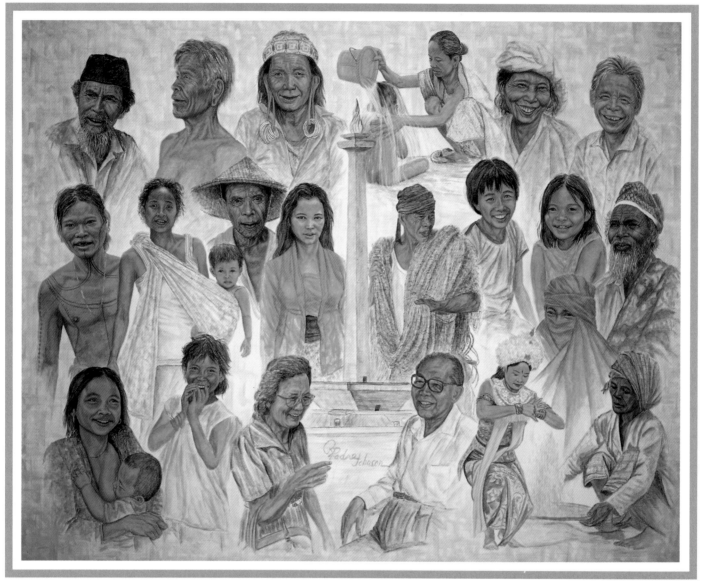

Portrait of Indonesia and the Phillipines 30" x 38" oil

"Eating together provides time for people to come together. It also provides the best opportunity for meaningful dialogue between friends and strangers. When you're invited to share a meal with people anywhere on this planet, you are also invited to participate in the openness of their soul. When you eat together with friends or the stranger from a foreign land, you almost always share open laughter, situation humor and the enjoyment of storytelling. In all societies, both simple and complex, eating is the primary activity for initiating and maintaining human relationships. It almost always provides an appreciation of a person from a similar or vastly different race, culture or social structure."

Indonesia, the world's largest archipelago, has more than 12,000 islands extending over 3,000 miles along the equator from Southeast Asia to Australia. Its major islands include Sumatra (roughly the size of Spain); Java, with its fuming volcanoes and scenic coasts; Sulawesi; Kalimantan, which occupies three-quarters of Borneo, the world's third largest island; Irian Jaya (the western half of New Guinea); Maluku; and Misa Tenggara, which is called the greater Sundas. The lesser Sundas stretch from Bali to Timor.

The country is divided into twenty-seven provinces with more than 60 percent of Indonesia's 175 million people living on Java. With the exception of exotic Bali (also densely populated), the rest of the archipelago is sparsely inhabited because so many of these equatorial islands are covered with jungles, forests and mountainous volcanoes.

Indonesia's ethnic diversity is greater than perhaps anywhere else in the world. More than three hundred different groups and roughly three hundred distinct dialects coexist in this vast array of islands, although most of the cultures and languages derive from the Malay as does the national language, Bahasa Indonesian.

Two factors, however, have served to unite Indonesia's diverse and scattered peoples: three hundred years of Dutch colonialism (which ended with Indonesia's final independence in 1946) and the religion of Islam. Since its arrival in the thirteenth century, Islam has been a powerful bond, and today nearly 90 percent of the population is Muslim. The republic's constitution, however, also guarantees religious freedom and recognizes such other theologies as Catholicism, Protestantism, Buddhism and Hinduism.

The Javanese have long been the most numerous of Indonesia's people. As leaders of the independence movement against the Dutch, they wisely chose to use the language of the "Market Malay" (of the sailors and traders) as the national language of the islands. They also refer to their multiracial and multicultural philosophy as "Unity through Diversity" *(Bhinneka Tunggal Ika)* and promulgate a belief in a just and civilized society with equality for all.

Yet even with this communal spirit, Indonesians pride themselves on their individualism and the characteristics that make them distinctly and interestingly different. The Bataks, for instance, are very outgoing and outspoken, whereas the Javanese are more reserved and quiet. But tolerance and a healthy respect for all is the rule, as is the belief that everyone has certain innate artistic capabilities. In fact, art, theater, dance and music are all an integral part of Indonesian life, as well as a love of festive occasions. Indeed, the Indonesians possess an amazing capacity for inventiveness and a genius for keeping themselves entertained. Works of art, especially wooden carvings, are produced on most of the islands, and the sounds of laughter and music can be heard in every village. To this day, Indonesia remains a kind of gallery or stage where everyone is an artist. The island of Bali at the eastern tip of Java exemplifies this attitude, for there every night is filled with the music of the gamelan and with children dancing the legong.

With a population of sixty million, the Philippine archipelago stretches over 1,150 miles off the coast of Southeast Asia and consists of over 7,000 islands and islets. Eleven of the islands, however, compose 94 percent of the total land area, and the largest, Luzon, has the nation's capital, Manila, with over eight million residents. The majority of Philippine people have Mongoloid features and are of Malay stock, descendants of Indonesians and Malays who emigrated to the islands long before the era of Spanish colonization. The first to occupy the Philippines were the Negritos, forest dwellers who are believed to have arrived 30,000 years ago across a land bridge from Borneo and Sumatra. In the ninth century, Chinese merchants and traders also settled the island of Luzan. In the fourteenth century, the Arabs came and introduced their religion, Islam. Next came the Spanish in the sixteenth century, who dominated the region until 1898 when the Americans gained control. And finally, independence came to the archipelago on July 4, 1946. But whether Chinese, Islamic, Spanish or American, all contributed their own special influence on the Malays to create a diverse population of racial, cultural and religious mixtures.

Although the uniqueness of the Philippines is less apparent today than it was fifty years ago, the country has certain striking distinctions that separate it from its neighbors. Among the more notable is the Filipino emphasis on public education and the prevalence of English, both heritages of the American era. In fact, literacy in the Philippines is as high as in Singapore and much higher than in most other Southeast Asian countries. The archipelago also has eighty-eight native languages all belonging to the Malay-Polynesian linguistic family, with Tagalog forming the basis of the official national language, Filipino.

Another peculiarity of the Philippines is its religion. The Spanish converted most Filipinos to Roman Catholicism during their four hundred years of rule, and consequently, the Philippines are the only predominately Christian region in Asia. American missionaries also spread various Protestant beliefs among the area's more remote tribes. Today, 85 percent of the population is Catholic and about 4 percent Protestant, and wherever one travels, parish churches dominate the landscape and serve as hubs for community life. Priests and bishops still command great respect, and the colorful folk festivals held everywhere, with their processions of Spanish saints, quickly reveal the lasting impact the West has made on Filipino society. Yet the lifestyles of the islanders continue as they have for centuries—relaxed, carefree and basically simple. For the Filipinos remain friendly, curious and open and, despite their often troubled and unstable past, are a people intensely interested in politics, public affairs and democratic values.

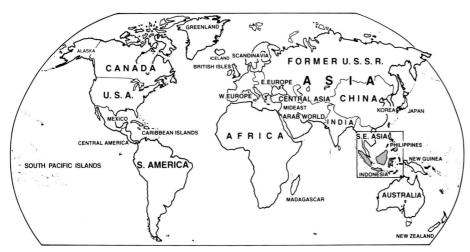

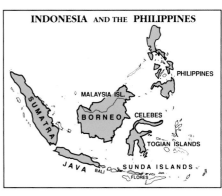

INDONESIA AND THE PHILIPPINES

NEW GUINEA

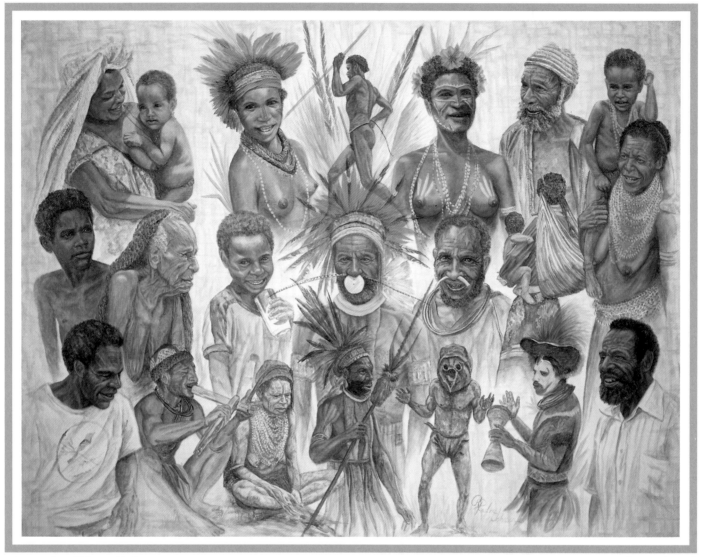

Portrait of New Guinea 26" x 34" oil

"As I have penned many of the insights for this book, there remains a sadness in my soul as I helplessly watch the winds of change slowly erode the fresh, uncluttered natural beauty of many of the open-souled, indigenous societies I touched and appreciated through my twenty-five years of global traveling. It is a misfortune that is impossible for me to adequately translate. Even now, as my next thoughts are being formed, particles of our world's national, tribal, ethnic diversity and cultural uniqueness are passing into the archives of our memories, only to reappear during festivals. But that is a reality that we must live with as we attempt to keep alive the soul and health of our traditions of color, clothing, ornamentations and cultural rituals which mark the past in the historical present."

The first Europeans to sight New Guinea, the world's second largest island (only Greenland is larger), were Portuguese and Spanish navigators sailing the South Pacific in the early part of the sixteenth century. The island was named in 1545 by the Spaniard Yugo Ortis de Retez because of the close resemblance its inhabitants bore to the people he found along the African Guinea coast. In 1975, after less than a century of colonial rule by Germany, Great Britain and Australia, the island's eastern portion became the state of Papua New Guinea—using the original Malay word for the frizzled quality of Melanesian hair, *papua*. Indonesia took over the western portion of the island from the Dutch in 1963 and renamed it Irian Jaya, the word for New Guinea in the Indonesian language.

Though the island has changed its name and boundaries several times, the spectacular mountain scenery and lush green rain forests remain almost entirely unmolested by advanced technology. Their size and difficult terrain are certainly major reasons why this land with a population of only 3,500,000 contains so many different cultures, their customs differing almost as widely as the diversity of their more than one thousand languages and dialects.

Over the years the origins of the New Guinea population have also been the subject of many disputes. Obvious to even the casual observer, there has been a considerable genetic mixture through history that most anthropologists agree extends back to the arrival of its original inhabitants more than forty thousand years ago. For example, the range of skin color varies from an almost matt black to a very light coffee color. Considerable variation is even found within villages, as well as between them. Though most anthropologists would agree that the people of New Guinea differ racially from the Australian Aborigines, there is evidence that both are partly linked by a common ancestry.

Despite the wide diversity in race and language, the various societies show many common characteristics and a firm identity. Among the features the people of this Melanesian island express so freely in their faces are a very proud, independent, happy, uncluttered spirit; a natural ritualistic enjoyment of family life, entertainment and elaborate ceremony; and a decorative color and magical rhythm in their native dance and song.

New Guinea societies also lack any form of inherited rank or chieftainship and almost without exception express a very aggressive individualism and sense of equality. Unlike many western societies, for example, in which people gain prestige by acquiring and displaying material goods, traditional New Guineans gain stature by exhibiting their largesse through the distribution of personal wealth in elaborate ceremonies. They also live in thousands of separate communities, most with only a few hundred people, divided by language, tradition and a complex system of allies and enemies which leads some to engage in tribal warfare with their neighbors even today. The last time I visited Papua New Guinea I spent time with the Melba people in the highlands. One community had just settled a score with an opposing neighbor, which resulted in several injuries and two deaths. However, within a short time, proper exchanges were made and peace was restored. In many tribal clans, this traditional payback system of swift justice and compensation for tribal infractions is still widely practiced throughout the island.

In some areas of Irian Jaya, the people cling more intensely to the old ways and modes of dress than in Papua New Guinea. My painting depicts traditional women's hair nets and grass skirts. Many hunters and warriors in the highland tribes in the west, known as the Dani, still wear the penis guard (*koteka*). Like the Dani, the people of the western mangrove swamps, called the Aswat, are friendly and free-spirited, but also warlike when provoked.

In recent years, Papua New Guinea has seen a considerable migration of people from the mountains and Sepik lowlands into the major western cities of Port Moresby, Lae and Mount Hagen, among others. Almost two-thirds of the population is now nominally Christian, blending tribal religious customs with Christian views. Of those who claim Christian affiliation, approximately 500,000 are Catholic and 325,000 are Lutheran, with the balance members of other Protestant denominations. Although the Christian churches are all under indigenous leadership, many foreign missionaries remain in the country. The indigenous non-Christian population takes part in a wide variety of traditional religious observances and ceremonies based on a system of spirit and ancestor communication.

As in many places on our planet, the pressure to discard traditional ways in favor of western lifestyles exerts a great influence on the social structure and ceremonial life of those who remain in the villages. A monetary system of exchange is replacing bartering, for example, and tribal leaders are forsaking their traditional roles for careers as politicians and businessman. Yet, in most areas, tradition still forms the base of everyday life, especially in more remote areas, where some tribal societies are almost untouched by the modern world, particularly by the effects of the country's current gold rush. These New Guinea natives, whose ancestors were among the first people on the planet to manage the forest for food, continue their subsistence economy, harvesting fish, coconut and such vegetables as sweet potatoes (*naskau*).

My portrait of the New Guinea soul presents a range of people from the thousands of open faces I enjoyed in eight tribes and many small communities, towns and cities. As I listened, laughed, danced and shared their food, stories, humor, patience, acceptance and love of family, I sensed our common spirit, an experience that clearly branded my memory forever in the most positive way.

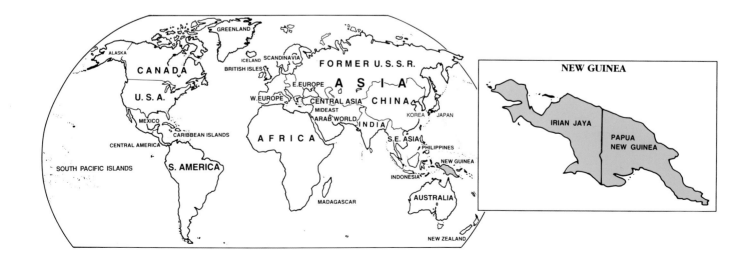

AUSTRALIA

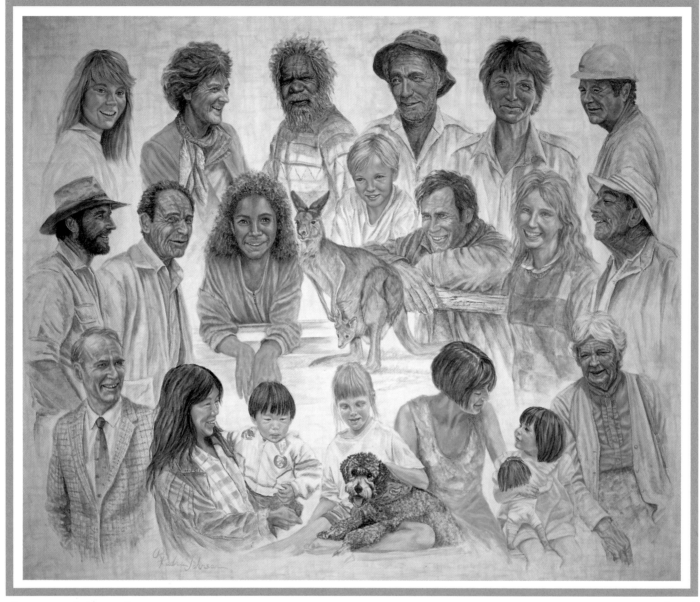

Portrait of Australia 30" x 36" oil

"When your face and eyes naturally reflect the spirit of an open acceptance and trust, which exists to various degrees in almost every person I've met, something very exciting occurs in the field of human diplomacy. The open child in each communicant is almost always released and prejudices in various degrees are dismantled."

With only a small percentage of its territory reaching above two thousand feet, Australia is a land of flat, seemingly unlimited, open space. One-third of the country is extremely arid, with an average rainfall of less than ten inches, and another third is semidesert. Rainfall also is so irregular in some areas that they may go without rain for years.

Conversely, the people who live in Queensland and the northern part of New South Wales experience a monsoon climate with hot, humid summers and regular heavy rainfall, followed by a dry winter and spring. Most of this land is used for raising cattle. In parts of southern Australia, the climate is similar to Spain and Italy, with adequate rainfall in the winter months, followed by a dry, hot summer. In this climate an early-harvested wheat grows well.

On the other hand, the Arnhem land in the extreme north is covered by bush, woodland, jungle and swamp. This territory, as well as parts of the central region, is inhabited by Australian Aborigines, who number about 130,000, although only about 45,000 are of full aboriginal descent. These nomadic people discovered the continent some thirty to forty thousand years ago. One of my Aborigine friends is depicted at the top of my painting.

At the present time, the government is granting special land rights to Aborigines in the northern territory. The new liberalized policies have stimulated the growth of self-determining communities in which traditional Aborigine heritage is blended with new cultural ways. Though the past can never again be recovered by most Aborigines, these policies have engendered new levels of respect for native people and their culture.

After each of my three visits to this "land down under," I have come away convinced that a bold, thoroughbred independence and adventure pervades this continent. Although visitors can detect Scottish, Welsh, Irish, and to a lesser extent English, influences, Australia is like no other place on this planet. It can neither be labeled British or American, despite its strong American influence over the past years, nor can it be labeled European or Asian. This vast, humbling environment evades definition, and any attempt to pin down its character is what the Aussies call mere "ghost gum"—elusive feeling. So what is left, with obvious exceptions, is a mix of people who are easygoing and like their new cultural counterparts, courageous, aggressive and competitive, with an independent savvy spirit and an indulgent passion for the outdoors, music, the beach and fun, not to mention a consuming passion for rugby and soccer.

Although many of the visitors I have talked with view Australia as white Anglo-Saxon, the real soul of the Aussie human landscape is a remarkable mix of cultures which continues to be enriched by new immigration. For example, Melbourne often is considered to be the third largest Greek city in the world outside of Greece. Middle Eastern and Southeast Asian migration has been substantial in recent years. Italians, Germans, Czechs, Dutch, Chinese, Indians and many others have certainly changed the delicatessen, supermarket and restaurant businesses. All have contributed to the gradual changing face of Australia since World War II.

Whether it's the Aussie lifestyle, the climate or Australia's open spaces, its new citizens have adapted more comfortably than in most other countries. This adaptive ease extends to the smallest details of life, including the Australian tradition of the barbecue with its plentiful supply of Australian beer. In fact, the ubiquitous barbecue is about as close as Australians come to a national cuisine.

In the face of rapid global change, the challenge facing these seventeen million Australians is to slow the pace and hold on to many of their traditions. Modern vehicles, for example, have made life easier for cowboys in the outback. But it tugs at the traditional heart strings to know that the long cattle drives still rely on the expertise of horseman.

Whether the people I have known have come from Australia's last frontier—the outback—the country or such major cities as Sydney and Melbourne along the Pacific seaboard, the spirit of freedom, adventure and magnificent open adaptability I have enjoyed in the Aussie people and captured in my portraits will always bring a smile to my face.

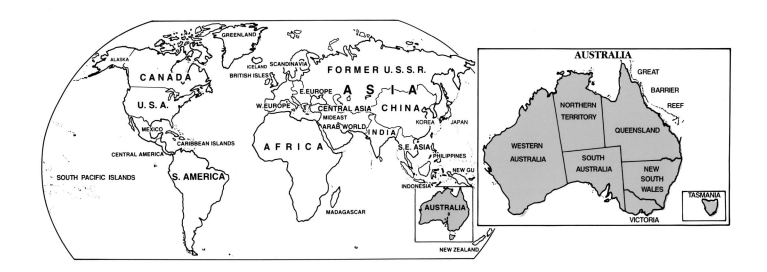

NEW ZEALAND

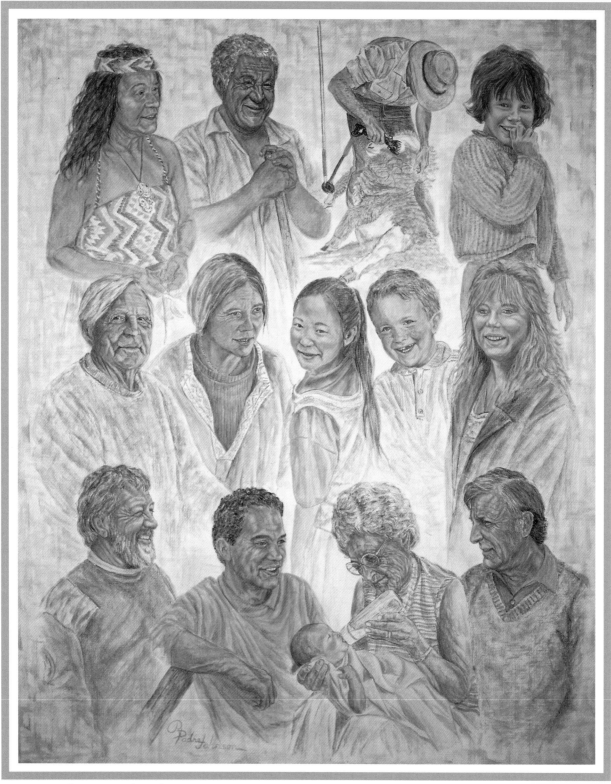

Portrait of New Zealand

24" x 30" oil

"There is a light at the end of the tunnel, which is difficult, but not impossible, to reach. If the portraits of the open faces I've enjoyed could serve in just some small way to encourage one person to trust another, then my years of global investment have been worth the effort."

New Zealand is an island of vibrant color and texture that stands in striking contrast to its neighbor Australia. With its majestic snow-capped South Island mountain peaks, exotic rain forests, wooded isles of glaciers, fjords, geysers and volcanos, its green-carpeted, back-country sheep stations, Kauri forests, kiwi plantations and the flightless kiwi bird (the name given to modern-day New Zealanders), New Zealand has a scenic wonder that will lure me back again to its intriguing South Pacific shores.

While Australia was discovered and settled by aboriginal people some forty thousand years ago, New Zealand was settled by Polynesians who came from South Pacific islands to the east just over one thousand years ago. Compared to the Australian Aborigines, these native New Zealanders, called the Maori, have a larger body structure, lighter skin color and hair that is more wavy than curly. Today the Maori, who number more than two hundred thousand, are a largely urbanized population.

When I visited New Zealand for the first time more than twenty years ago, the towns and cities were almost entirely populated with faces of Anglo-Saxon heritage. Except for a few tourist areas, the Maori were primarily confined to remote rural settlements. But by my last visit in 1988, they had moved into urban New Zealand, dramatically changing the face of its human landscape. With increasing numbers entering New Zealand's professional and business communities, most Maori wore European clothing and, with the exception of some of the elderly, spoke English. Most were also members of Christian churches.

Yet many still maintain strong links to their ancestral past, particularly when it comes to birthday celebrations, baptisms and funerals. Most Maori harbor a deep respect for their heritage beneath their western garb. Their close community celebrations and the sharing of common concerns reinforce their common identity. Due to the efforts of both Maori and non-Maori communities, New Zealand has been able to avoid some of the extremes of social and racial conflict experienced in other parts of our world.

Until recent years, New Zealand had one of the most homogenous populations of any country settled during the European colonial expansion of the late eighteenth and nineteenth centuries. Contingents of English, Welsh and Scots with a blend of Protestant and Catholic Irish immigrants scattered along portions of the west coast, introducing livestock farming (mainly sheep and cattle) to this wonderfully fertile soil. A mainstay of the early economy, this industry continues to make a major contribution to the economy of New Zealand.

Though white Anglo-Saxon Europeans (called pakehas by the Maori) still comprise roughly 80 percent of the population, all over New Zealand a broad cross section of other nationalities have added new ingredients to the kiwi melting pot. Today you can stand on a corner in a city like Auckland during rush hour and view almost the entire range of the country's diversity, from the Chinese who began immigrating in the last century to Scandinavians, Germans and the many Pacific Islanders who have provided a colorful look and sound to New Zealand society over the past two decades. Other groups include Greeks, Italians, Russians, Ukrainians, Chileans, Indians, Lebanese, Romanians, Dutch, Turks, Africans, Czechs, Hungarians and Southeast Asian refugees— all bringing with them their cultural ways, specialties and tastes into an evolving New Zealand culture. With the demands of a new urban and global economy, this is indeed a time of abrupt social and economic transition for New Zealanders, a period of subtle, exciting, pervasive and sometimes unsettling changes that are distinctively New Zealand in character.

The faces of the people I captured in my painting are representative of the endless diversity I enjoyed in my two journeys to this magical island. Despite the country's growing urbanism, most of its old and new faces still reflect an easy, fresh, uncluttered, hospitable and open spirit which is laid back yet determined and confident. There is also a strength and sense of honor and freedom that matches the land they inhabit. Today, the white, Maori and other South Pacific populations continue to merge through intermarriage. If I could return in another twenty-five years, perhaps I would observe another major color change with hopefully the best being retained from all origins, including the free easiness of the Polynesian culture as a balance to the stresses of our new world.

The expressions, color variations and feelings I've enjoyed in the New Zealand facial features and personality have their wonderful points of similarity in every global portrait I've included in this book.

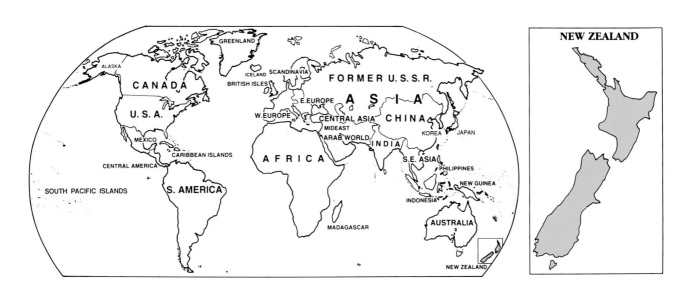

ISLANDS OF THE PACIFIC
Micronesia, Melanesia, Polynesia

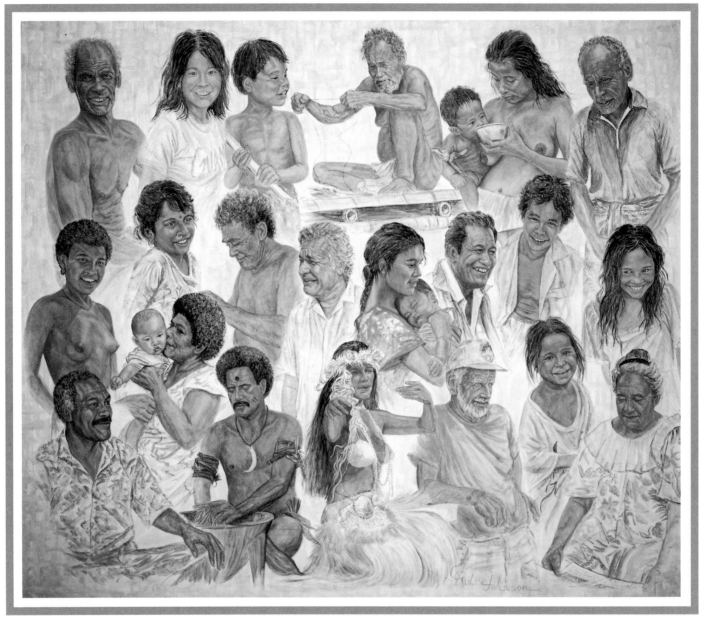

Portrait of Pacific Islands

32" x 38" oil

"The deeper I journeyed into the human forest, the more convinced I became that to effectively interpret the human family and truly make my work live and breathe on canvas as a credible artist, I had to personally experience the people, their ways of being human, their instincts and their sense of community and family living. This was the only authentic way I could successfully translate the pulse of their culture and the many emotions that spilled out of each soul."

The vast Pacific Ocean spans a third of the globe and covers 64,186,000 square miles. It embraces three broad divisions of Oceanic peoples and cultures: the Micronesians, the Polynesians and the Melanesians. As the word "Micronesia" suggests, these islands are very small and widely scattered across the western Pacific east of the Philippines. Their population numbers less than 300,000 with the main islands including the Carolines, the Marshalls and the Marianas, some of which were formed by volcanic eruptions and others by coral atolls. In contrast, the Polynesian islands, in the central Pacific, cover a much greater area than either Micronesia or Melanesia. In fact, Polynesia extends as far north as Hawaii, as far south as New Zealand, the Tuamotu Archipelago and the Society Islands (where beautiful Tahiti, Moorea and Bora Bora reign supreme) and as far east as Easter Island. Northeast of Australia, the Melanesian islands consist of New Guinea, the second largest island in the world; the Bismarck Archipelago; the Solomons; New Hebrides; New Caledonia and Fiji, which altogether form a bridge between the Western and Eastern cultures of the South Pacific.

The Micronesians, a mixed race of Melanesians, Polynesians and some Malaysians, tend to have Mongoloid characteristics. In general, they are short and slight with copper-colored skin and straight black hair, and divide themselves into clans. Like the Polynesians, the Micronesians are seafarers who fish the ocean for their livelihood and are also very skilled at weaving and basketry. Today, the majority of Micronesians are Christian, though many tend to blend elements of former tribal rituals into the ceremonies of their present day Christian beliefs. In western Micronesia, most are Roman Catholics, converts of the Spanish missionaries who arrived there in the early sixteenth century, whereas in the east more are Protestant, from their contact with the Americans and the British who went there at the end of the nineteenth century.

Polynesians also are a mixed race, perhaps related to the Malays, and tend to be much larger than the Micronesians. Their typical male, for instance, averages five feet, nine inches. Some Polynesians have relatively light skins and distinct Caucasian features with large faces, straight noses and wavy hair. While others, like the Tahitians, tend to be darker skinned with more Mongoloid looks. Some experts believe the first Polynesians migrated to the Pacific from India by way of Indonesia. Others think they came from South America, and still others contend they came from Southeast Asia via Micronesia. But despite the distinct cultures of each island group, all Polynesians have similar languages, fishing methods and hierarchical social systems, which originally emphasized a

cosmology with many gods. Little of those indigenous Polynesian religions survive today. By the late nineteenth century nearly all Polynesians, like the Micronesians, had been converted to Christianity.

Generally, Melanesians are shorter than most Polynesians, averaging from five feet to five feet, seven inches. They also have broader noses and larger lips with dark coffee to light brown skin and frizzy to wavy hair. In speech, custom and their degree of Westernization, Melanesians differ vastly from one community to the next. In eastern Melanesia, for example, the Fijians and New Caledonians are nearly all Christian, whereas in the more remote areas, tribal rituals and loyalties play a greater role in the daily lives of the people. The linguistic diversity of Melanesia, too, especially in New Guinea where more than 1,000 languages are spoken, contrasts markedly with the more linguistic homogeneity found in Polynesia and Micronesia. Moreover, Melanesian societies are usually smaller and far more egalitarian than those of Polynesia and Micronesia, where there is a far greater emphasis on hereditary and social rank. But curiously, all three cultures do have one thing in common: the use of kava and betel, intoxicating beverages made from the roots of certain pepper plants that are drunk at various ceremonies and family events.

Unfortunately, the original social structures and traditions of the Pacific island people have been disrupted over the past five centuries by various Western intrusions. Since Captain Cook's arrival in the eighteenth century, especially, the West has adversely affected the region, causing disease, commercial exploitation and wholesale plundering of the islands. The British, French, Dutch and Americans have all attempted to colonize the region, and even today, the United States maintains control over American Samoa and most of Micronesia. And smaller territories are still retained by Britain, France and New Zealand, with Indonesia ruling western New Guinea, which is now called Irian Jaya.

Yet in spite of continued Westernization of the Pacific islands, the people there remain tied to the natural rhythms of their tropical environments. They live simply and openly, and maintain a healthy romance with the ordinary everyday rhthyms of life. From the very young to the very old, their smiling faces truly reflect a carefree joy and genuine happiness with existence. Their friendliness, hospitality and sense of humor and independence will always leave its imprint on those who take the time to appreciate the fascinating blend of cultures, races and ethnicities that make up the exotic Pacific Islands.

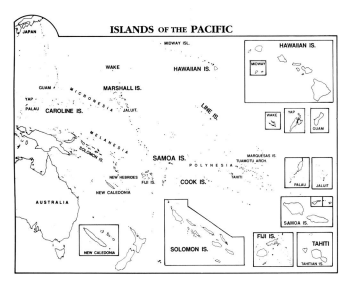

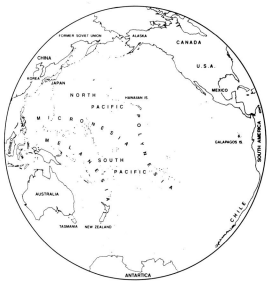

CONTINENT OF SOUTH AMERICA

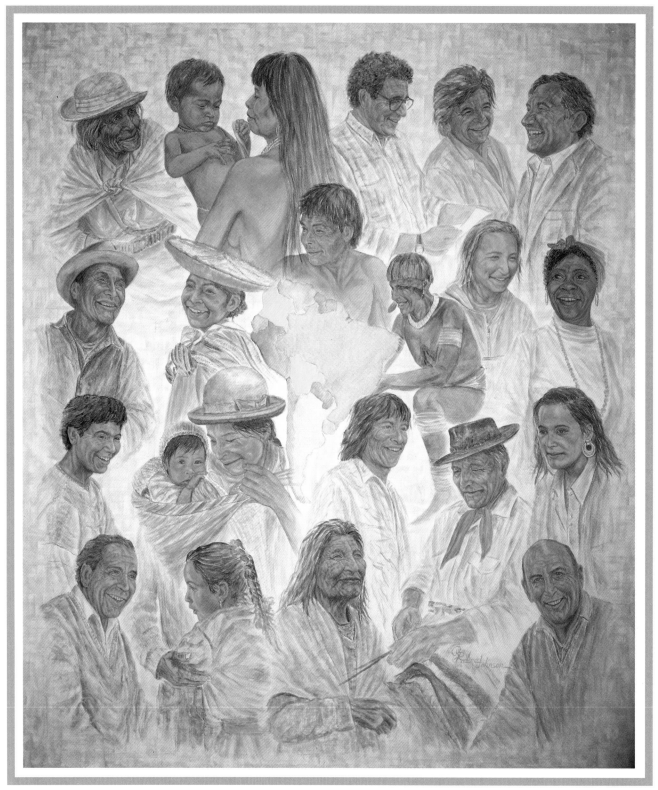

Portrait of the Continent of South America 34" x 40" oil

"My global journey has certainly not been a lonely journey. On the contrary, it was marked with unlimited adventure and opportunities to give and receive, explore and appreciate the soul of each culture and the open, trusting character of every person with whom I played, laughed, danced, ate and shared my humanness."

The geography of South America harbors some of the world's most complex and ancient natural diversity. The Andes Mountains, the longest mountain chain on any continent, stretches nearly five thousand miles along the western edge of South America, boasting more than thirty-five peaks along the way. Three-fourths of the continent's land mass lie in the tropics, where the world's largest rain forest covers millions of acres under a dense canopy of vegetation. The jungle, scored by the vast Amazon River system, remains an inhospitable terrain for most South Americans. Instead, this heartland is home to a few remaining Indian cultures, which still live in some ways that resemble their ancestors.

Most geographers divide the continent into two distinct areas—the highland Andes and western seaboard and the eastern-seaboard lowlands and Amazon region.

With its tropical latitudes and high mountains, the west coast of South America comprises a fascinating ecological diversity which exerts a profound influence on the social and political life of the entire region. In Colombia, Ecuador and northern Peru, for example, the Andes narrow and allow for tropical jungle along the Pacific coast. In southern Peru and Bolivia, the mountains broaden into bleak, windswept plateaus with altitudes of thirteen thousand feet, where fishermen navigate vast inland lakes, such as Lake Titicaca, using the reed boats of their ancestors. In northern Chile, the broad belt of the Atacama Desert cuts across the Andes.

Before the arrival of the Spanish conquistadors in the sixteenth century, this region cradled some of the most sophisticated civilizations of the New World. For a variety of reasons too complex to mention here, a handful of Spaniards in 1532 captured the entire Inca empire in a few months, battling its citizens for forty more years until the Spanish gained complete possession.

Today, the people of the northern Andes are either Spanish, *mestizo* or Indian. Though the Spanish remain a minority after four hundred years, their impact extends to every aspect of life, including religion, language, culture and technology, and they continue to be leaders in both government and business.

Yet this region is by no means a second Spain. Though Chileans are predominantly of European origin, the large majority of the population is *mestizo*, people of mixed Spanish and Indian blood. And the Andes are still home to many thriving Indian communities. Unlike the coastal or river Indians, who were decimated by Europeans in search of rubber, diamonds and gold, highland tribes often were protected by rugged, impassable terrain. Estimates say that there are more Indians in the Andes today than at the time of Spanish conquests. In Bolivia, for example, more than 55 percent of the population is Indian, while in Peru the number stands at 50

percent and in Ecuador 30 percent. Remarkably, even though most Indians speak Spanish and are Roman Catholic, a few groups, such as the Quechua peasant farmers, still speak the language of their Inca ancestors.

The eastern portion of South America reflects its Portuguese past. In 1494 Spain and Portugal divided the continent between themselves, both largely ignoring their conquests, however, until the sixteenth century when the French, English and Dutch began to take an interest in the continent's riches. The Portuguese staked their first claim east of the Andes and soon thereafter Portuguese immigration began flowing into present-day Brazil.

More than half of the population of eastern South America is of mixed Amerindian, African black and European descent, reflecting its immigration history, including the four million blacks who were brought from Africa by Portuguese slave traders. In Paraguay, for instance, almost 96 percent of the population are *mestizo* descendants of the Guarani Indians and sixteenth-century Spanish settlers.

The most notable exceptions to this ethnic mix are the pampas of Argentina and Uruguay. There people of Spanish and Italian descent make up almost 90 percent of the population. In Guyana, East Indians, mostly from Madras and Calcutta, India, comprise about 40 percent of the population. In Brazil, the ethnicity of the country's 150 million people is geographically divisible. In the north, people of Indian, African and European descent predominate, while the south is largely peopled by recent European arrivals, including Scandinavians, Germans and Italians. There are also many Japanese communities.

Until recently, the nearly impenetrable Amazon jungle has kept immigrants from the heart of the rain forest. Today there are about 150 remaining tribes numbering three hundred thousand people in the Amazon region. Some tribes, such as the Arawak, Tupi, Carib and Jivaro, are agriculturists occupying the Amazonian forest basin from central Venezuela to the mouth of the Amazon River. But perhaps most displaced by Amazonian development and mining are the hunting and gathering societies, whose numbers have dwindled to only a handful of tribal groups.

My journey took me to the tropical jungle and temperate grasslands, the coast and the interior, to twentieth-century cities and the amazing pampas, where I raced horseback with the fiercely independent, free-spirited gauchos.

Each time I traveled to South America I partook of many unique forms of hospitality which come from this continent's special blend of cultural, ethnic and racial history.

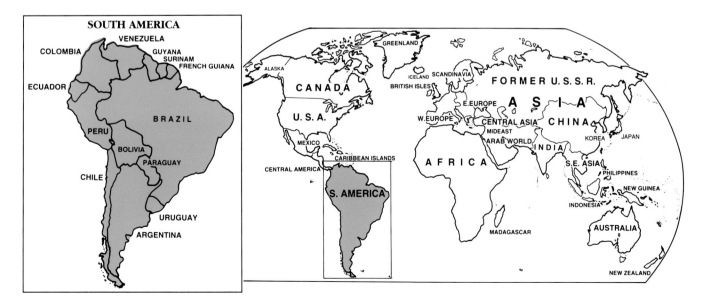

MEXICO, CENTRAL AMERICA & THE CARIBBEAN

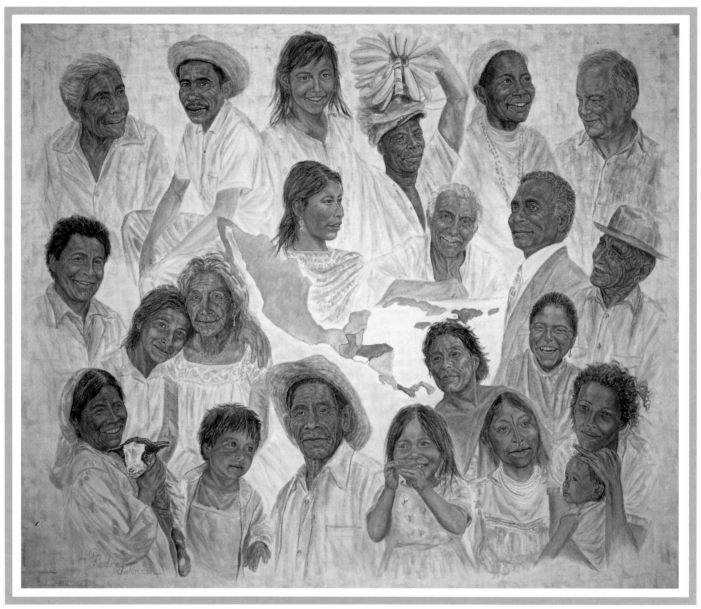

Portrait of Mexico, Central America and the Caribbean 30" x 36" oil

"Most people would agree that much of our world is controlled by economic and political greed and thoughtlessness, and yet, in spite of this abrasive reality and its disregard for the welfare of people who simply desire the dignity of human respect, I continue to believe that there exists deep in the soul of every person a wellspring of goodness."

Much of Middle America's diversity in landscape and culture can be attributed to its unique geography. The region comprises a land bridge that connects two continents of the Western Hemisphere skirted by an island chain of almost Edenic beauty. The Rockies and the Andes meet in the narrow waist of Central America. To the east the mountains disappear beneath the sea and then reemerge as the 1,500-mile-long breakwater of the Caribbean Islands.

Though rich in scenic splendor, (Costa Rica has been called the Switzerland of Central America and the Dominican Republic "the fairest land under heaven" by Columbus), the mainland and island nations of Middle America, except for Cuba and Honduras, possess little cultivatable land. Ironically, the Indians of Central America introduced the world to such crops as corn, lima beans, sweet potatoes, peppers and many other edible plants. Today, on their limited, but very fertile, soil, the republics of Central America produce an important share of the world's bananas. Though the smallest, most industrialized and most crowded country in Central America, El Salvador grows enough coffee in its rich volcanic soil to make it the world's ninth leading coffee grower. And the Caribbean is a major producer of sugar cane.

Just as the Mediterranean once served as a pathway for western civilization's advance across northern Africa and Europe, so the Gulf of Mexico and the Caribbean formed an opening to the New World. Across this soil, nation after nation vied for the possession of land. Today the Spanish language and culture predominate, but the Dutch, English, Asians, French, Portuguese and African slaves also have left their indelible mark on the land and its native Indian populations, whose civilizations ranged from the primitive to the advanced societies of the Maya and Aztecs. Mayan mathematical sophistication, for example, developed the concept of zero, and their calendar was more accurate than the European's. These two civilizations were even more remarkable because they used no metal (except to adorn their bodies), no animal power or wheel transportation.

Today Middle America's racial mix shapes this entire region into a unique political, cultural and ethnic mosaic. The contrasts are striking. In the cities, the shacks of the poor surround modern office buildings, factories and villas. Democracies and dictatorships exist side by side in friendly common-market exchange. Devout Catholic Indians burn incense to native gods on the steps of local churches or during religious festivals decorate their streets with a blend of ancient and Catholic religious imagery. Though in many countries, Spanish may be the official tongue, the *mestizo* (a person of mixed Spanish and Indian blood) often speaks more comfortably in one of the Mayan or Aztec dialects of his or her ancestors. In addition to the *mestizos*, the population includes mulattos, people of Spanish and African ancestry. In a few areas, people of African heritage remain ethnically distinct as, for example, the black Caribs of Guatemala.

When the Spanish conquered Mexico and Central America in the early sixteenth century, they named the inhabitants Indians, using the name Columbus gave to the people in the West Indies. At the time of Spanish conquest, the people were divided into many kingdoms and tribes. Though they were of Mongoloid ancestry, according to many present-day anthropologists, they varied in physical type, language and cultural achievement.

Within two decades, almost all of Mexico and Central America was under Spanish domination. Armed confrontations and European diseases decimated the native populations. In time, African slaves, already introduced into the West Indies to replace the dying Indians there, were imported to work in the mines and on the sugar plantations of Mexico and Central America. Mixed Spanish and Indian populations soon began to outnumber the Spanish.

In the nineteenth and twentieth centuries, Middle America also saw an influx of Italian, Scottish, Irish and German immigrants. In fact, one of the outstanding features of the Caribbean, for example, is that it is populated almost entirely by immigrants. My travels throughout the islands was a rich ethnic experience unlike any other island group in the world. The blending of European and African cultures and, to a lesser degree, East Asian and East Indian, along with the original Carib and Arawak cultures has created in the past few centuries an immensely rich diversity. These multiracial societies with skin colors ranging from a rich black to the palest shades of cream reminded me of a fleet of assorted ships afloat in the Caribbean.

What they share, however, is a colorful, joyful and easy lifestyle. The hospitality is so open and friendly, as is so often the case with people who live close to the soil and take delight in simple pleasures.

This vitality remains true for countries like Mexico, even though the populations from the countryside continue to migrate to such urban meccas as Mexico City, which at twenty million people is the largest city in the world. Even with its urban overcrowding, there is a life and color which makes Mexico a high spot in Latin American development. Today Mexico ranks as the world's fifth largest oil producer. It also is rich in such mineral resources as gold, copper and iron.

And it is rich in culture. Contemporary artists, architects, writers, musicians and dancers continue to draw inspiration from Mexico's rich Mayan and Aztec civilizations, colonial history and revolutionary past, as well as contemporary contrasts. It is a land where a conservative German-made car and souped-up Japanese motorcycle pass a barefoot country boy tugging his burro, where a dark-suited businessperson strolls past peasants hawking their services near modern office buildings. Though Mexican and Central American music may have its roots in Spain and obtain its fiber from natural Indian rhythms, its soul springs spontaneously from inventive genius and from letting life flow out and all around. These wonderful people, who always seem to be eating, have always provided me with their time and their spiritually open face.

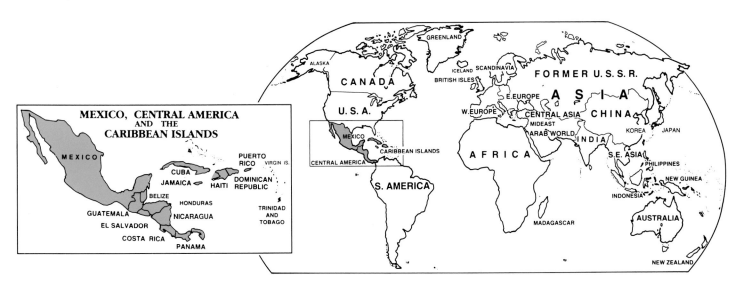

THE UNITED STATES OF AMERICA

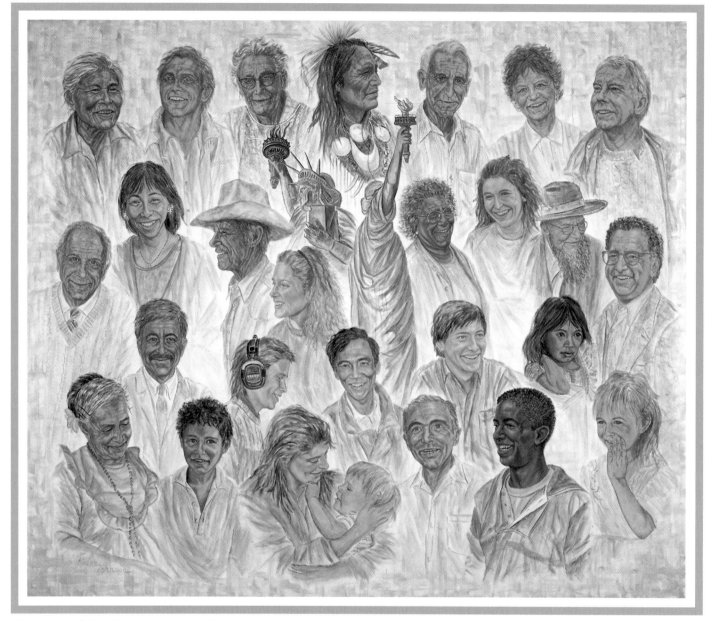

Portrait of the United States of America

34" x 40" oil

"There are times when I perceive the wonder of this vast expanse of global humanity with its billions of individual souls as a fascinating mosaic which does not fuse, but links and respects the dignity and traditions in each family unit. At other moments, I picture this amazing global panorama as a vast rain forest with an unlimited blending of colorful tree, bush, plant and leaf variations. Similarly, as in the life cycle of the rain forest, each human person is also unique to his/her own form, but interdependent on other members of the human forest."

To a newcomer, perhaps the most striking feature of the United States of America is its size—3.5 million square miles—making it the fourth largest country in the world. Covering the entire middle portion of North America, the United States stretches from the Atlantic Ocean in the east to the Pacific Ocean in the west. It also includes Alaska in the continent's northwest corner, and Hawaii, a group of Pacific Islands first settled by the natives of Polynesia. Within this vast territory are landscapes of great diversity. Travelers on the country's great superhighways pass cities bustling with skyscrapers, as well quaint rural towns, rolling fields of grain and corn and breathtaking snow-capped mountains.

Populated by approximately 250 million people, America has had a long history of colonization. According to the earliest archeological finds, it was settled more than eleven thousand years ago by the ancestors of the Alaskan Innuit (Eskimo). They were Mongoloid hunters and gatherers who most likely migrated before the decline of the Ice Age from Siberia. European migrations began in the sixteenth century with the Spanish and were followed in the succeeding two centuries by settlers from England, France, Germany, Ireland, the Netherlands, Scotland and Scandinavia. In the late 1800s, large groups of Southern and Eastern Europeans began to arrive. This influx reached its zenith between 1901 and 1910 when nine million immigrants entered America from all over the European continent. People from China, Indonesia, Japan and the Philippines also began to reach U.S. shores in the late 1800s, followed by Koreans, Vietnamese and other Asians in the late twentieth century.

Two monuments perhaps best sum up the heart of America. "Give me your tired, your poor, your huddled masses yearning to breathe free," reads the inscription on the base of the Statue of Liberty in New York's harbor. Though written more than a century ago, these lines still contain one of the core truths about the USA: that it is a nation built by people who came from somewhere else, and almost all with the same purpose—to better themselves and to find political, religious and social freedom.

This sentiment is more formally articulated by the Declaration of Independence, housed in the National Archives in Washington, D.C. "All men have the same unalienable right to life, liberty and pursuit of happiness" and that "government exists to secure those rights and when it fails the people have the right to abolish it and institute a new government....We the people of the United States, in order to form a more perfect union, establish justice, insure domestic tranquility and secure the blessing of liberty...do ordain and establish this constitution."

The history of this nation has and continues to witness a balancing act between these abstract ideals and actual practice. With few exceptions, the European settlers regarded American land and its resources as raw materials to be mastered for their own use and enjoyment. Extremely rich in the natural resources vital to a productive economy, the U.S. is one of the most highly developed in the world. Its large expanses of fertile soil sustain some of the earth's most productive farms. Its wealth of natural resources, such as coal, iron ore, natural gas and petroleum, among others is matched only by the former Soviet Union. Consequently, in terms of material wealth, most people in the USA enjoy one of the world's highest standards of living.

This prosperity originally disinherited the country's native peoples. To the Indian, the land and the living things upon it were gifts to be revered, not wasted or conquered. Native American/Indian populations were nearly exterminated as immigrants pushed the frontier west, taking Indian land and destroying their culture and means of existence. They were the freest of all people, which is why, ironically, I placed my friend Roy "Eagle Feather" Peet in traditional ceremonial dress, worn at a recent Cody, Wyoming, pow-wow, between the arms of the Statue of Liberty near the top of my painting.

Prosperity was gained at the expense of other injustices as well. Not all migrations to the United States were voluntary. Most black Americans are descendants of Africans slaves brought to this continent during the seventeenth, eighteenth and nineteenth centuries. In 1865 a constitutional amendment during the Civil War declared that "neither slavery nor voluntary servitude—shall exist within these United States." Other amendments followed, yet little progress for African Americans was made towards full civil rights until the 1950s when civil rights became a critical political issue, resulting in many improvements in employment, income, education and political representation. Movements among Mexican Americans, Puerto Ricans and American Indians paralleled the blacks' fight to realize the nation's ideals for all peoples. Today, eight of the fifteen most populated cities in America have black mayors.

Thus, in many important ways, America continues to live up to its reputation as a melting pot. According to the latest census, this country is home to people from 178 of the 179 nations on earth. Though the vast majority speak English, dress similarly and eat the same foods, many have retained the traditions of their ancestors. Visit just about any city and you'll find people of different national, ethnic and racial origins still living in ethnic enclaves or celebrating their own festivals, parades and religious events.

Admittedly, Americans have problems with racism, unemployment, drugs, crime, greed and homelessness. Yet, as I have crisscrossed the country's fifty states, I have found that you can freely speak your mind without fear of incarceration, a right guaranteed by the First Amendment to the Constitution, which states: "Congress shall make no law respecting the establishment of religion or prohibiting the free exercise thereof; or abridging the freedom of speech."

And I have discovered that by and large goodness is still the trademark of the American character. There is a friendliness, neighborliness, decency and a great determination and humor that still breathes in this land. It's a response I have captured in the faces of my USA portraits.

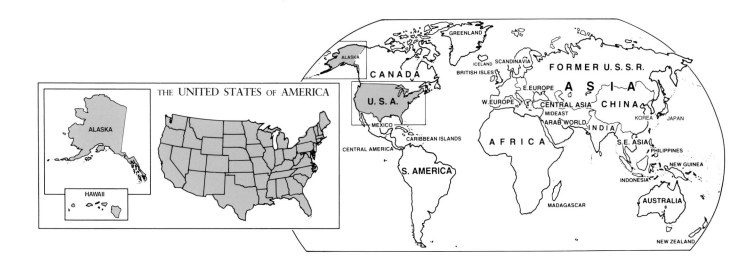

CANADA

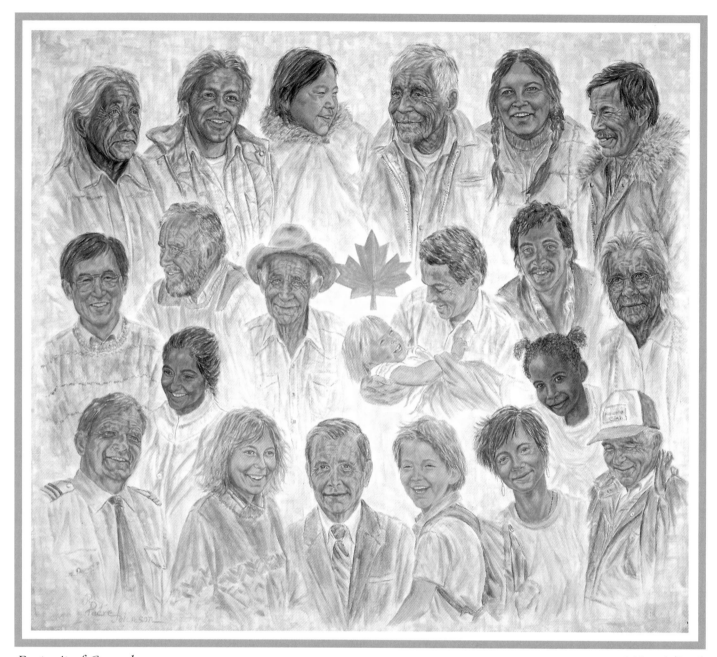

Portrait of Canada 30" x 34" oil

"*If just one face I've photographed, painted or sketched could serve as the lens through which a viewer is able to appreciate a brother or sister of a different color, creed or culture, then I will have fulfilled a key objective in my global project. Even more significant, if viewers pass on this acceptance to others, they will make a meaningful contribution to increasing the spirit of harmony and goodwill among the global citizens of this planet.*"

Although at 3,831,033 square miles Canada is the second largest country in the world, it has one of the smallest populations—twenty-six million people. This vast country comprises a federation of ten provinces and two sparsely populated territories—the Yukon and Northwest Territories—whose Arctic winters and remote location keep all but the hardiest 1 percent of the population away.

The country's wealth of natural resources makes Canada one of the world's most prosperous nations. Its fertile prairie farmlands, large mineral deposits (Canada is currently the world's leading exporter of minerals), vast forests and rich fishing waters contribute to its highly developed economy.

These immense spaces encompass a landscape of mind-boggling variety and grandeur. Canada's natural beauty ranges from towering mountains and thousands of crystal-clear lakes to lush green forests and the vast prairies and wheat fields of its south-central farmlands. To the north lies a majestic windswept Arctic terrain.

Nearly 80 percent of Canadian residents live within one hundred miles of the U.S. border. Unlike their southern neighbors, most Canadians tend to view their country as a cultural mosaic rather than as a melting pot. The composition of cultures on Canadian soil resembles a kaleidoscope of peoples who have retained their distinctive characteristics and yet learned to live together with good will.

This harmony is as much the result of design as of chance. In addition to many government programs that encourage cultural diversity, Canada even has a minister for multiculturalism who is responsible for promoting the best interest of the nation's thirty-two ethnic constituents. However, assimilation with the dominant Canadian cultures—British and French—is common. French and English are the country's official languages, with approximately 65 percent of Canadians speaking only English, 18 percent only French and almost 14 percent bilingual.

Nearly 30 percent of Canadian citizens are descendants of French settlers of the seventeenth and eighteenth centuries. Most French-speaking Canadians live in the province of Quebec, whose capital is the city of Quebec. As a result, Quebec differs somewhat from other areas of the country. Its rural areas, in particular, maintain a rich and active French culture whose unique language patterns and customs reflect their French Canadian heritage and differ in small but important ways from continental France.

Canada's politics and economy, however, are still dominated by its English background, with a very strong influence from its Scottish, Irish and Welsh heritage. The population of Canadians from other non-British backgrounds equals that of the French Canadians, though their lack of cohesion makes them a less influential force in Canadian life and politics.

Nonetheless, a wide range of immigrant groups has made the cultural transition to Canadian life, including a well-established Italian community in Toronto. Undaunted by the cold and isolation, immigrants from Norway, Sweden, Finland and Iceland viewed the vast northern territories as a land of opportunity. These Northern Europeans number close to 2 percent of the population. German-Canadians make up the nation's third largest ethnic groups and are considered to be among the most prosperous. In many areas of western Canada, Polish, Ukrainian and Russian immigrants have established successful farms and agricultural settlements. Today there are also sizable numbers of immigrants from the warmer climates of India, Pakistan and Sri Lanka, including immigrants from large Indian settlements in East Africa and Fiji. Many of the East Asians have found success in the Canadian retail trade. The more than three hundred thousand Chinese, living mainly in the Chinatowns of Vancouver and Toronto, have dramatically changed the multicultural shape of Canadian life by electing the first Chinese-Canadian member of parliament.

Ironically, the only groups with minimal participation in the decision-making process are the indigenous Indians who occupied the land thousands of years before the Europeans arrived. These former hunters and gatherers still feel an internal clash between their culture and the demands of the advancing technologies of this century. Today there are approximately 317,000 registered Canadian Indians of various tribes with title to more than two thousand reservations. About one-third of this Indian population lives permanently outside the reservations. Though few still practice their subsistence economy in the north, most Indians still depend on fishing, trapping and hunting to supplement their incomes.

Such organizations as the Assembly of First Nations, however, have given many tribes an emerging political influence. The Innuit, for example, are becoming increasingly active in politics. These original settlers number approximately twenty-seven thousand and are divided into eight groups throughout the Northwest Territories. Yet all speak the same language, with English, and less frequently French, as a second language for most. With the exploitation of the far north's mineral resources in the last few decades, the Innuit have been increasingly exposed to modern ways. Though today only a few follow their traditional way of life—seal-skin boots and caribou parkas, for example, are still worn—there is a growing awareness of the need to protect their heritage through traditional celebrations and education. This effort has been spearheaded and encouraged by the Foundation of the Brotherhood since 1971.

Today, many national programs are making a concerted effort to accommodate the needs of all races and nationalities embraced by the Canadian mosaic. Canada's live-and-let-live policies recognize that the vitality of its economic and social life is due primarily to the energy and insights of its many different cultures and racial groups.

On my many visits to Canada, I was openly and generously invited into the homes and workplaces of its citizens where I enjoyed their friendly souls, hospitality and diverse lifestyles. The individual but common expressions I captured in each of my open-faced portraits also represent the millions of other similar faces I've enjoyed throughout my global journey.

BHUTAN
My Shangri La

Portrait of Bhutan

20" x 24" oil

"No race, ethnic or religious group, possesses a superior awareness or intelligence over any other on this miniature earth in the limitless space of our Universe. With only different modes and levels of opportunity, we are all children of a common family learning through a similar pre-school curriculum the expression of living and giving."

Surrounded by the dramatic Himalayan Mountains of Tibet to the north and India to the south, this little nation, known as the land of the "peaceful dragon," has produced a fiercely independent, self-sufficient people.

In this centuries-old monarchy, most Bhutanese live in the traditional ways of their ancestors. It is a land where the magic of sound, color and spirit is reflected in balanced lives and happy, curious faces. In this close-knit, family-oriented society, where social and educational opportunities are open to everyone regardless rank or birth, I have walked many peaceful streets where people sing while they work and mothers carry their secure babies on their backs.

The grandfather depicted in the foreground of my painting is the respected patriarch of a large family of thirty-two members. The three-story house which shelters his entire family reflects Bhutan's unique architecture, a style reminiscent of a mix of Persian design and Swiss chalets. Its ingenious function and design are the result of traditional uses and craftsmanship handed down over generations. The top floor, for example, is an open-sided granary, where wheat and other staples are dried and stored. The entire structure is constructed using wooden pegs instead of nails, and heavy stones hold down the shingled roof to prevent damage from strong winds.

The Bhutanese demonstrate their cultural unity in many aspects of daily life, particularly in their national dress. All men wear a kho, a long white cuffed robe, whose fabric is tied around the waist to form a pouch. The traditional kho is so popular it is worn even by the king, who eschews plain white, however, in favor of a checkered pattern. The women wear a kira, a beautifully colored, full-length robe.

This artistic flair permeates Bhutanese festivities and rituals as well. They are not only a very musical people, but as the dramatic masked figure at the top of my painting illustrates, they have preserved the extraordinary grace and color of their ritual dances. Dance lies at the heart of all Bhutan religious festivals, as does archery, the national sport and centerpiece of all athletic events.

The Bhutanese have embraced a sect of Buddhism as their state religion. Throughout the land, sounds and symbols, such as the prayer flags that stream from the roof tops carrying messages to the wind, bear witness to the deep respect the Bhutanese have for their religious traditions. Because this piety is so strongly rooted in the soul of these people, I placed an old Buddhist monk instructing a novitiate at the center of my painting.

AN INSIGHT INTO MY ART
AND CREATIVE PROCESS

From my childhood, I have exhibited a spirit of freedom and risk which has seasoned my life with a series of unusual adventures. As far back as I can remember, I've pursued a desire for exploration. With the encouragement of some and the concern of others, this sense of freedom has allowed me to achieve a level of creative imagination which, in its most uncluttered form, continues to generate a wonderful acceptance of my humanity and an easy excitement about the adventure of living.

My early curiosity was clearly evident in the portraits I used to sketch with unusual anatomical accuracy from the age of ten (my encouraging parents preserved the evidence in their scrapbook). That early expression of intuitive/open-ended awareness served as the key ingredients in shaping a very satisfying and fulfilling professional art career.

As I cross the threshold of our century's last decade, I am nearing the completion of a two part thirteen year project/adventure to document my impressions of the human family in every nation on planet earth. In paintings and sketches, my interpretive journey with the people of this planet presents an important visual statement concerning the interesting differences in each individual and culture and the limitless threads of similarity which pull us all so closely together as one interdependent global family.

I believe that a work of art reflects an artists interpretation of the purpose of human existence and their connection or dislocation with the world. We all do interpret the meaning of life from events and influences that are either slightly or vastly different from someone even as close as our nearest sibling. Each human face and personality is as unique as each individual fingerprint. Similarly, each artists' interpretive rendition will always carry the unique touch of the artist. No two artists are exactly alike; there are only similarities. Even where two very close artist companions with similar interests, have utilized the techniques of the same mentor, their skills of interpretation and artistic expression remain uniquely different.

As a member of this very diverse creative profession. I bring to the creative process my own uniqueness resulting from a singular combination of life events and influences. Whether the subject matter is western, wildlife or portraits form around the world, my art represents the valued interpretation of a personal-historical journey. Through the use of brush, charcoal stick, pen and pencil and the spoken word, I have truly enjoyed the fulfillment of sharing my insights and my reverence for all life with so many people in so many places. For the opportunity to realize the indefinable value of this dream, I remain extremely thankful. My art is the visual instrument which will hopefully allow these valued insights, principles and historical markings to endure.

From the conception of a work of art to its ultimate statement of being, the exercise of my free-spirited imagination is perhaps the most important ingredient in the creative process. Clearly, I'm more interested in revealing the spirit of my subjects than merely their external form. It is this spirit sensing involvement with my subject matter which opens many of my viewers to sense and feel a deeper identification and a discovery of the larger symbolic meaning behind the visual subject in my work of art. Many of my viewers have commented that they have seen a deeper meaning behind the surface expression in many of my portraits and wild life renditions which has engendered a renewed sensitivity towards all living creatures and the land we are responsible to nurture and protect. Stimulating this awareness is one of my highest priorities.

As a craftsman who has received many prestigious awards for my western, wildlife, and portrait art, I continually strive to improve the authentic quality of my art, by moving the viewer beyond the visible subject matter, to say as much in my painted or sketched rendition as the viewer's creative imagination can absorb. Everything I create should work as a comprehensive well-coordinated whole in which the

composition of color, shape and mood captures the vitality of the original subject on canvas or paper. The breathing quality that I always seek to achieve should motivate viewers to see beyond the initial contact with the painted or sketched subject and discover its extended meaning.

I exclusively used live models earlier in my career. However, as with most of my realist contemporaries who need to catalogue vast amounts of usable material, I also use photographs as an authentic record. With reference to my Faces of the World project, the constraints of global travel did not allow for adequate time and space to utilize live models except in rare occasions, when, for example, I sketched the open, uncluttered faces of my Kalahari Bushmen friends as a gift for their personal enjoyment. Photos admittedly offer the luxury of sufficient time in which to ponder the creative process and the ultimate statement I wish to make. They also serve as a convenient vehicle through which my creative imagination is channeled.

My creative process also involves a very lengthy preparation period. Before I determine the acceptable composition, I spend hours retracing my memory, in a concentrated effort to recall the magic of sight, sound, taste, smell, touch and all the other remarkable moments of openness which are captured by the images in my photos.

As I contemplate and eventually translate the photo image onto canvas, my brush literally feels its way into the soul of the subject matter I have personally experienced. In this process my identification with the photo image is inseparably connected with a very vivid memory process that includes the use of all my senses.

With but few exceptions, I sketch and paint the people, animals and places within the context of their living situation. In my global faces project, I had to personally experience the soul of the people in their real daily living situations before I was able to capture the most effective feeling, mood and color compositions in each portrait image. Each of the hundreds of faces rendered on my twenty six canvases and additional sketches is complete in and of itself. Yet at the same viewing they all may be perceived in the totality of its context, reflecting the exciting diversity and notable similarities in the entire global human family.

R. Padre Johnson

THE BEGINNINGS
OF MY
PROFESSIONAL
ART CAREER
IN
OIL, CHARCOAL
AND PENCIL

*An insight into my
Western, Wildlife, Scenic
and other Portrait renditions*

With one of my four horses on the Padlock Ranch during a pause on the Diamond Bar high country range.

I received my start as a professional artist in the field of Western Art. In the following renditions of my western experience, I capture a uniquely diverse Western Americana view into the life I lived in Wyoming and Montana. With reference to the American horse and saddle cowboy culture, I have been able to project an effective transfer of mood and life to canvas because I have tasted, smelled, listened and observed very carefully as an actual working member of the few remnants which still link the contemporary 1980's with the historic high country and range cowboys of the last century. Certainly not in all, but in many respects, the horse and saddle cowpuncher I worked with is very similar to his rugged predecessor at the turn of the century. As one participant in the vast array of talent which attempts to capture its past and continuing essence and create a valid statement concerning our contemporary western heritage, I feel privileged to have been able to live and work with some of its most authentic remnants.

MY INTERNATIONAL AWARD WINNING WESTERN ART

A View into my Western Experience as a Working Cowman in Wyoming and Montana

Riding my horse, Midnight.

Ghost Riders in The Sky 36" x 42" oil

One afternoon as I and two saddle companions rode in search of stray cattle in the high country, a passing hail storm formed the most ghostly sky I had ever seen. As the cloud scudded over, one of my cowboy friends began whistling the cautionary song, "Ghost Riders in the Sky". Months later, I began translating the lines of the famous ballad to canvas. This is the dramatic result: an elemental expression of a popular myth at the heart of the cowboy roundup experience.

"An old cowpoke went riding out one dark and windy day, upon a ridge he rested as he went along his way — As the riders passed on by him — horses snortin' fire — one came out to call his name, if you want to save your soul from hell a ridin' on our range then cowboy change your ways or with us you will ride, a tryin' to catch the devil's head across these endless skies."

This type of "slow movin' dreams" magic was captured while working as a cowboy and outrider with one of the last horsedrawn chuck and supply wagon outfits in the American West, the Padlock Ranch. The viewer of this painting takes their place from my saddle in the early morning movement toward a new destination and camp site. Not shown in this painting are the following 40 horses being guided along behind by the remaining eight cowboys in the unit. Each cowboy has a string of four horses.

Movin' Out on the Padlock 24" x 36" oil

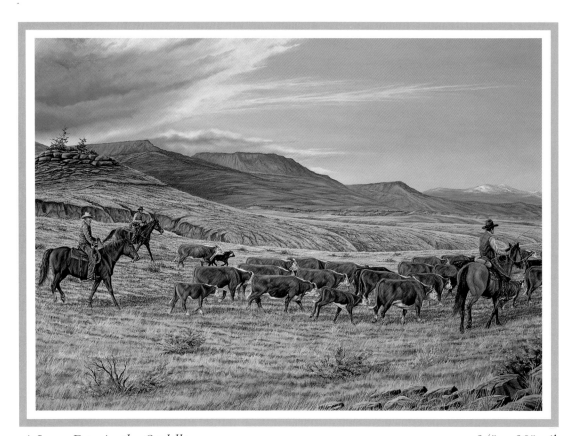

A Long Day in the Saddle 34" x 30" oil

During the Padlock's annual spring roundup and branding on their 320,000 acre range, the days are long in the saddle and hard in the branding pit. Yet for me and my cowhand companions, our sweat and saddle is our freedom. To move along with the slow moving, rhythmic, hypnotic sounds of our cattle and horseflesh and breathe in the clear scent of the open range cultivates a feeling of romance with nature for which there is no complete definition.

During an extended break on the fall roundup with the Trial Creek Ranch in Cody's high country, I observed my friend and saddle companion, Charlie Blackstone, in a twin-like mood of dreamy contemplation with his legendary horse. It was the right moment and the perfect image from the only remaining American culture which still maintains a direct functioning link with the 19th century. This is a unique work, showing an almost mystical unity of nature, man and horse.

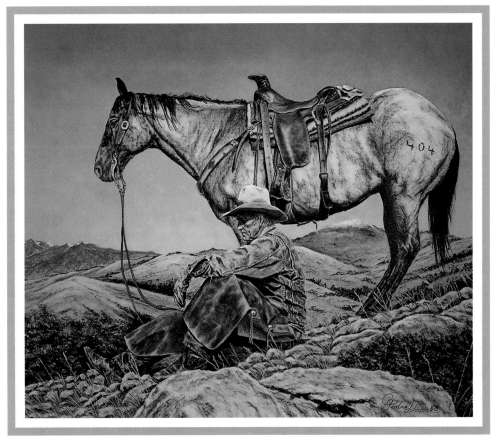

Old Leather Denim and Dreams 20" x 24" oil

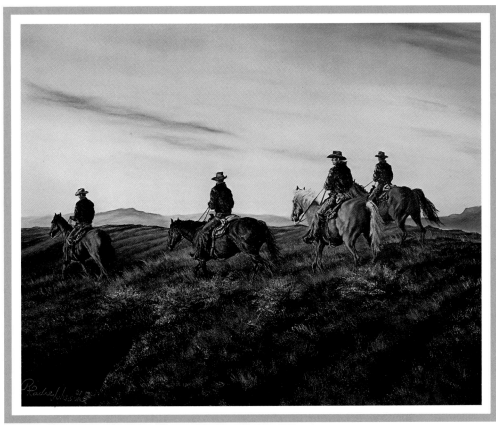

Early Morning Circle 24" x 30" oil

This painting on the Padlock captures that mystical moment just before sunrise when the first evidence of the herd still lies beyond your vision. You sense on the sounds, scent and feel of horseflesh and leather, the early morning breeze and the peaceful mood changing colors reflecting new life off the range grass and sage.

While moving among this and other bands of wild horses during roundup time in the McCollough Peaks region in Northwest Wyoming, I experienced perfect timing in recording the explosive energy of this wild chase through the gap.

The physical texture of the many bands roaming this area is some of the finest among America's wild breed.

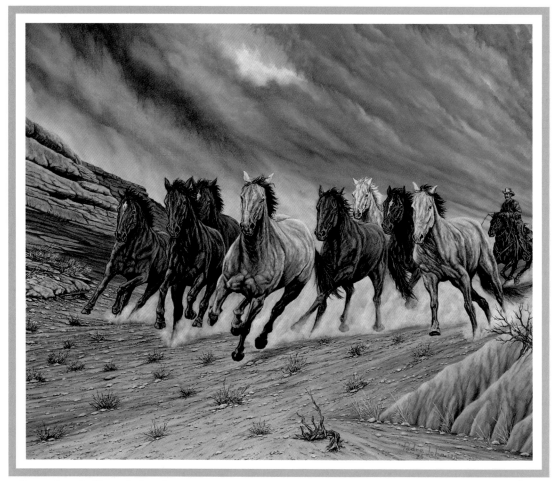

Chase McCullough Peaks 30" x 36" oil

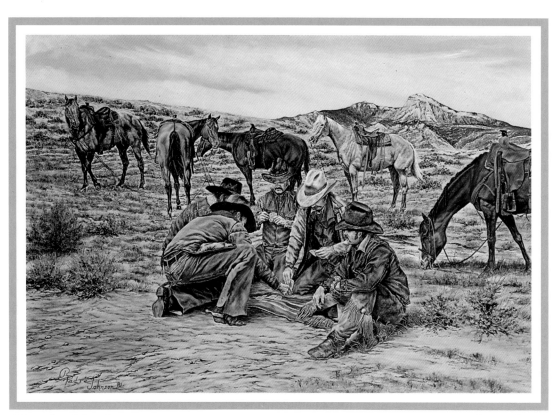

Five Card Stud 24" x 36" oil

After a long day of working cattle on the Trail Creek Ranch, Monte suggested a few games of stud poker as the most natural form of mid-afternoon relaxation.

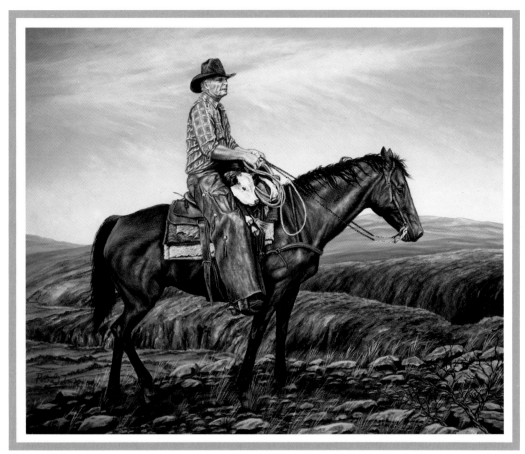

While working the spring roundup and branding, I looked back to see my friend and cowboss drop down to pick up a new calf who was struggling to make the drive over the next imposing ridge. A few minutes later I caught this rare but candid feeling of protective security and satisfied contemplation on Freddie's face as he paused to observe his herd moving along and over the next ridge.

Shepherd of His Flock 20" x 24" oil

This painting captures an exceptional moment of tender love and expectation following my, and Billie's, hard day and return to the high country cow camp/corral at sundown. When little Lannie meets her daddy, tender feelings are always shared. Again, I was in the right place and time.

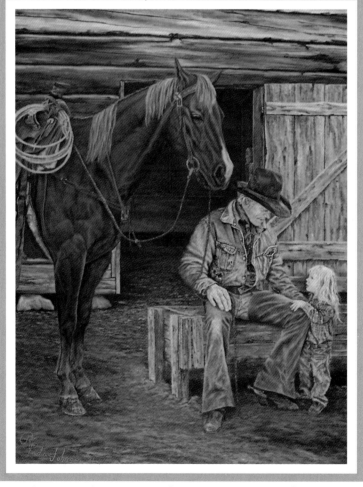

Sundown at the Diamond Bar 24" x 30" oil

A View Into My Adventure With The Wildlife Scene of North America and Africa

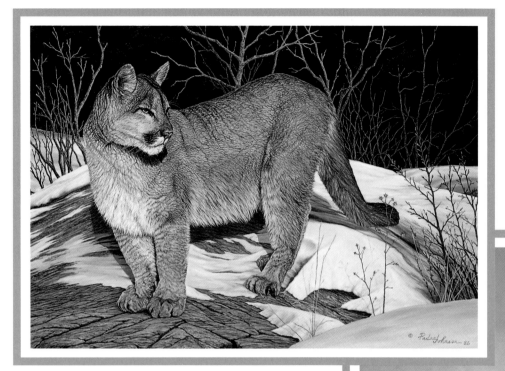

The title of this painting barely describes the feeling I've experienced in my encounters with the fascinating skill and regal grace of the illusive North American cougar.

The eyes convey a thousand thoughts.

Grace & Power
24" x 36" oil

This majestic Rocky Mountain Bighorn Ram was photographed on the North Fork near Cody, Wyoming, just four miles from my mountain log home. In his prime, this dark coated Ram had won it all. Aware of my silent presence, he declared with a confident body movement and a perceptive eye that I was trespassing on his territory. This was his land.

The Monarch
20" x 24" oil

The setting for this oil takes place on my private land 20 miles West of Cody, Wyoming. Both the magnificence of the Yellowstone range and the spirit of freedom inspired by the majesty of the golden eagle who frequently touches down on this old lightning scarred tree, creates new inspiration and meaning to the words majestic and free.

Majestic & Free
24" x 30" oil

This canvas was reproduced from photos taken from an actual charge on our position during a photo safari in Northern Botswana's Okavango region. My companion, Izak Barnard, one of Africa's most distinguished guides, said that this charge was among the most exciting yet frightening experiences in his 25 years as a professional guide.

Charge Along
the Chobe
22" x 28" oil

There is nothing quite so spectacular as the sight of a Pacific Blue Marlin erupting in all its majestic leap for freedom from the deep blue waters of the Pacific ocean.

The Majestic Marlin
20" x 24" oil

According to my journal, the day after the elephant charge, I took a series of photos of the beautiful splendor and grace of the Saddlebill stork in Botswana's Okavango Region.

The Saddlebill Water Ballet
20" x 24" oil

93

PAINTINGS OF SCENIC WONDER

Grand Tetons 22" x 28" oil

From this serene oil you can feel the sense of romantic tranquil majesty with the subject, the Grand Tetons near Jackson, Wyoming. Following my climb of the Grand I was commissioned to paint this piece.

Aspens in Autumn Gold 20" x 24" oil

This oil reflects the romantic, aesthetic, peaceful feelings which are so deeply implanted in my soul.

SKETCHES OF THREE UNIQUE CULTURES
A View into the Open Faces of Southern Africa's Kalahari Bushman

Today there are only a few Bushman families that live as their ancestors did and as I experienced them in 1982. Living, sharing food and dancing with the Kalahari Bushman was truly one of the most exceptional experiences of my life. These last few aboriginal people survive in a harsh unyielding environment. Yet due to their highly developed skills and their ability to adapt to the rhythms of their natural environment, they survive as hunters and gatherers.

In my view these last few stoneage remnants are some of the most civilized people I have ever met. From them we could learn that to be truly civilized is to share their sense of human personality, contagious uncluttered sense of humor, open laughter, natural curiosity and excitement for living.

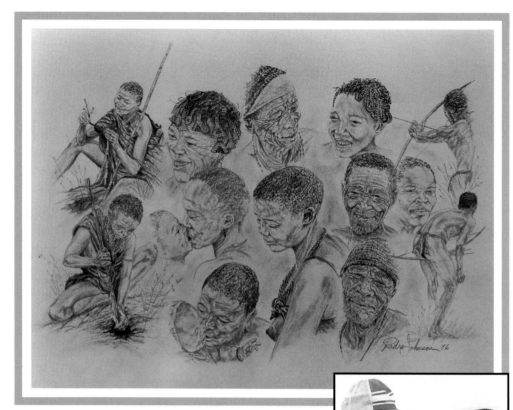

The Kalahari Bushman
18" x 24" pencil

*With my Bushman friend
Bet Knei*

In this oil a farmer is followed by his wife, patiently seeding the furrow. The sacred yak of Tibet is one of the most efficient all purpose animals in the world, supplying almost everything the Tibetan nomad requires. Along with their service in the field, they provide the world famous yak butter, milk, meat, wool for their tents and clothing. Their dung, sun-dried into hard bricks, is used as fuel or building material. They also provide transportation as a saddle or pack animal. Although they look large and clumsy at first sight, they're surprisingly graceful, moving swiftly on dainty hooves with their long hair dancing in the wind. When bred with domestic cattle, their offspring is the versatile dzo, like the plowing mate to the hairy yak in the painting.

Yak Plowing in Tibet 18" x 24" oil

The charcoal sketch to the right portrays an open enjoyable conversation between me and my Russian farmer friend, Ivan. This market place verbal exchange not only reflects our enjoyment of thought and humor, but a very special sense of human acceptance, similar in spirit to that of the Bushmen. The two cultures seemed to melt into a deep appreciation for the other person. It was like conversing with a favorite friend. I enjoyed the luxury of speaking a very poor but passable Russian.

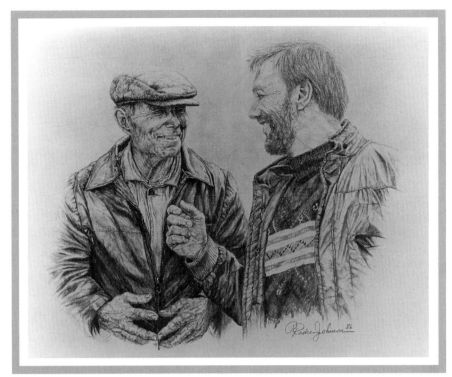

Acceptance – My Russian Friend 18" x 24" charcoal

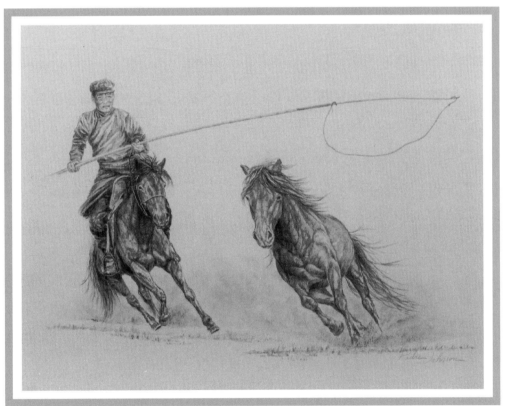

Mustang Roundup in Mongolia 18" x 24" charcoal

The Mongolian is one of the finest horseman in the Far East. I rode and raced with the Mongols. In this sketch, the master of the Mongolian mustang reaches out his urga, a fifteen foot birch pole with a leather noose, to rope a wild Mongolian horse. The Mongolian horse is a small but tough, quick and highly treasured by the Mongol herdsman.

THE RACE
I lost a close challenge to champion Mongolian horseman Ching jou Getu at their festival. This angle shot is a bit deceiving.

Ching jou Getu and I after our horse race in Mongolia

A VIEW INTO
SOME FACES
OF THE
NATIVE AMERICAN
INDIAN

The faces represented in this triad of tribal diversity comes from my own personal experience and insights developed through my working relationship with a wide range of Native American Indian communities.

The eyes are the entrance to the soul in each rendition. They speak a thousand words and interpretations.

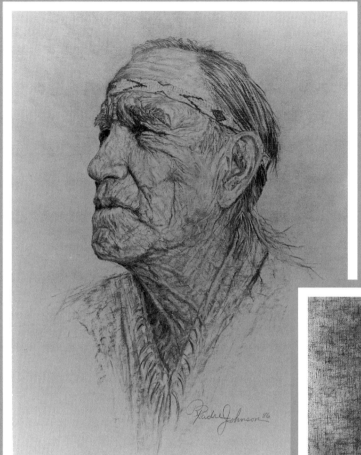

Redcliff *The Old Hopi Patriarch and Medicine Man*
20" x 24" oil

Dakota Jack *A Dakota Sioux*
18" x 24" charcoal

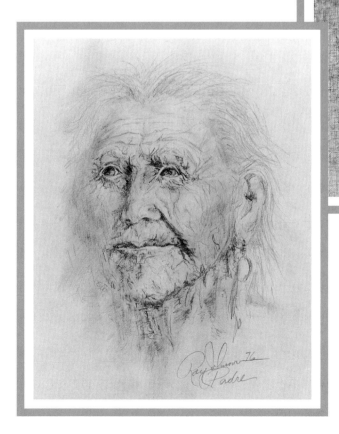

"Running Waters" *A rough free-style sketch of an older Chippewa woman.*
11" x 14" pencil

A VIEW INTO THE FACE OF HUMAN SUFFERING

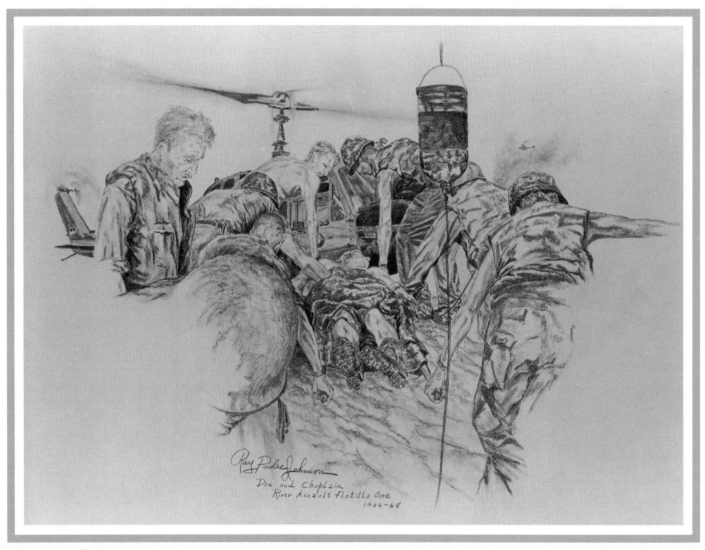

The Face of War 18" x 24" pencil

I sketched this moment of intense survival from a photo that was later given to me by our unit's special forces photographer, Tom Shinton. He was caught in the same ambush with me. My helmeted face is returning to another casualty in the painting's foreground. The story of this battle was recorded in Time Magazine. There were over two-hundred casualties to my friends and comrades that day. As their Medical Chaplain I was with many friends who were reaching out for both my medical help and spiritual-emotional encouragement on that dark and cloudy day. I also was wounded later on that day.

In all candor their is no adequate translation for the eye to eye bloody encounters that I experienced along the river banks of Vietnam's Mekong Delta. Perhaps the clearest interpretation is reflected in the hopeless, helpless fatigued face of the young man on the left side of this sketch. That says it all.

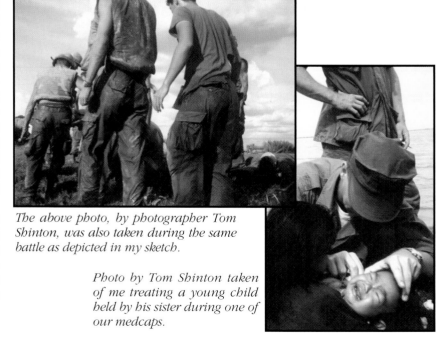

The above photo, by photographer Tom Shinton, was also taken during the same battle as depicted in my sketch.

Photo by Tom Shinton taken of me treating a young child held by his sister during one of our medcaps.

"We all feel pain, hunger, discouragement and loneliness in similar ways. We all express a common thread in the fabric of our survival instinct. In this arena there is no color difference."

"At times throughout my life I have experienced the face of suffering and desolation in ways that have caused my mind and spirit to feel utterly helpless and empty."

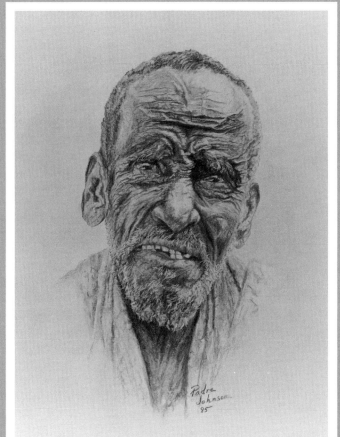

The Face of Human Suffering
18" x 24" charcoal

This interpretive sketch speaks for a thousand words and faces in the memory of my journey through the nations of our planet, the face of war and the markings carved on the endless faces of emotional fear and stress as close as your next door neighbor.

In this global facial image there is still a lingering silent expression of ones dignity and inner strength that will hopefully survive beyond the helpless fatigue and confusion of the present condition.

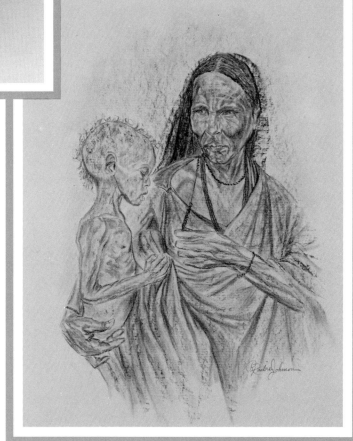

The Face of Hunger
18" x 24" pencil/charcoal

Drought and political selfishness by their government leaders have caused this mother and child to walk for miles through intense heat to seek food. Only the most severe heart rending hunger, starvation and illness could force these self-reliant people to trade their nomadic freedom for food.

THE CIRCLE OF LIFE
The Fabric of His Life
Jesus of Nazareth

The model for this oil sketch painting is a Russian Jew who is both a carpenter by trade and a counselor by vocation. I used his basic features; then added 10 years and a slight reshaping to his features to capture a concept which reflects the hard work, wind, dust and sun of a natural environment in which Jesus lived. His rough hands but gentle spirit provided the perfect combination for this portrayal which is sketched out in the form of a life circle. In various degrees, we all experience the five elements of Jesus' life I have brush- stroked onto this canvas.

The portrayal on the right depicts the Jesus who reflects a very natural laughter — one who is free to risk the ridges of living. Moving clockwise, the face of Jesus changes into a feeling smile of tenderness and a complete open trust and acceptance between Jesus and the child. It was this open trust and acceptance which Jesus used as the example to finding true meaning in our human existence. I used the model's own child in this centerpiece portrayal. The deep compassion Jesus felt for the nameless people we usually miss is depicted on the left. Note the face of the woman who Jesus touches with a feeling of care.

The images of the crucifixion, are slightly reduced in size in order not to dominate the life circle. Moving clockwise, you sense a deep suffering, physical pain, loneliness and doubt which we have all experienced in our darkest hours ("My God, why have you forsaken me?"). The last portrayal is also our final earthly experience in which we enter into the peace of God through death ("Into Thy hands I commend My Spirit"). The resurrection into peace and new life is depicted by the whites, blues and royal purples in the outer drippings of the painting. This will always remain a matter of faith.

As the medical chaplain to a special forces unit in Vietnam, 1967 – 68 (twice wounded), I worked to salvage the lives of many of my comrades under extreme combat conditions. I don't believe I would have been able to capture the struggle, pain and death of the crucifixion if I had not experienced this myself with so many mortally wounded who moved from that struggle to live, and the question, "God where are you?", into that same face of peace in death that my interpretation portrays on this canvas.

The markings follow the recent research where the spikes penetrated the wrist in place of the palm. The early European artists were both unaware and unfamiliar with the triple meaning of the Greek word, "Cheiros". This word includes the wrist and forearm as well as the hand. Thus, the image of the spike penetrating the palm was our most familiar image, until the most recent research was made available.

The "X" mark, portrayed by the crossed arms, is a symbolic sign of protection and salvation in the Jewish tradition. In the Greek, in which the New Testament was written, the letter "X", spelled CHI, and pronounced "ki" (long "I" sound) is the first letters for Christ (Christus).

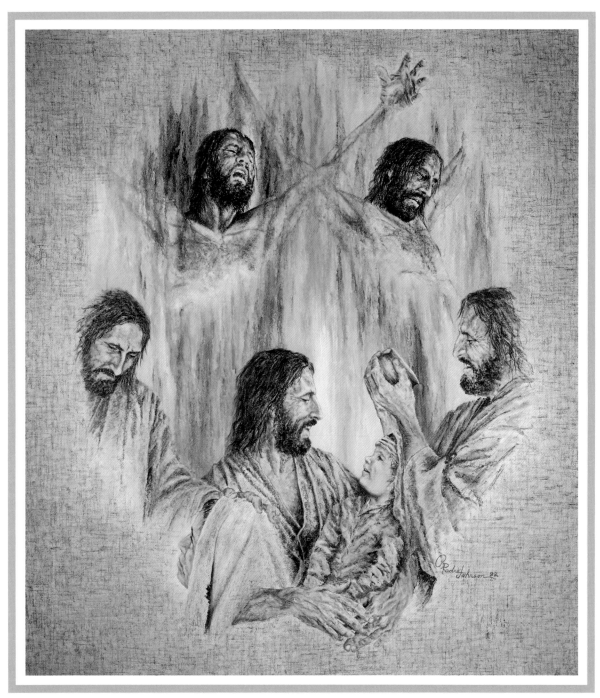

The Fabric of His Life/Jesus of Nazareth 40" x 44" oil

Karl Gustav XVI
King of Sweden

The King seen with me at the private showing of my art for the King and Queen Sylvia who confided to me and other guests that he was intensely moved by the humanity of this piece. The King and Queen have this and two other pieces of my art.